HERNE BAY
THROUGH TIME
John Clancy

AMBERLEY PUBLISHING

First published 2015

Amberley Publishing
The Hill, Stroud, Gloucestershire, GL5 4EP
www.amberley-books.com

Copyright © John Clancy, 2015

The right of John Clancy to be identified as the
Author of this work has been asserted in accordance with
the Copyrights, Designs and Patents Act 1988.

ISBN 978 1 4456 4023 5 (print)
ISBN 978 1 4456 4032 7 (ebook)

British Library Cataloguing in Publication Data.
A catalogue record for this book is available from the
British Library.

Typesetting by Amberley Publishing.
Printed in Great Britain.

Introduction

This book is essentially the story of Herne Bay, one of Britain's earliest seaside resorts, situated on the north Kent coast overlooking the Thames Estuary, 7 miles (11 km) north of Canterbury and 5 miles (8 km) east of Whitstable. It neighbours the ancient villages of Herne and Reculver, both of which are an integral part of Herne Bay and will therefore be featured in this book. In 1833, an Act of Parliament established Herne Bay and Herne as separate towns, and local landowner Sir Henry Oxenden marked the occasion by donating a plot of land on which to build the town's first church, Christ Church, which was opened in 1834. The landscape of the town has been largely influenced by the Plenty Brook, thought to have been a much larger stream in ancient times, which flows northward through the centre of the town and into the sea. The Plenty Brook now passes through the town's drainage system, allowing buildings to be built over the top of it, but it is prone to flooding during heavy rain, especially in inland areas, which regularly causes problems for people living in the Eddington area in southern Herne Bay.

The coastline has two distinct bays separated by a spit of land created by a build up of silt from the outflow of the brook into the sea. The first buildings in the town were constructed along the east bay, a short distance from the brook's outflow, where the road from Canterbury meets the sea. The town has since spread across both bays, the Plenty Brook valley and onto the relatively high land flanking both sides of the valley. To the east of the valley the land rises to a height of 25 m (82 ft) above sea level, and to the west 10 m (33 ft). Cliffs are formed where this high land meets the sea. The rising land beside the coast, between the valley and the eastern cliffs, is known as The Downs, an area that has been designated a 'Site of Scientific Interest and a Special Protection Area for Birds'.

Herne Bay took its name from the neighbouring village of Herne, situated a mile or two inland from the bay. The word 'herne' means a place on a corner of land and evolved from the Old English *hyrne*, meaning 'corner'. The 'corner' may allude to the sharp turn in the Roman road between Canterbury and Reculver. The village was first recorded around 1100.

The town began as a small coastal community where goods and passengers from London en route to Canterbury and Dover landed. Passenger and cargo boats regularly ran between Herne Bay and London, and boats carrying coal even came from as far away as Newcastle. From Herne and Herne Bay there was easy access by road

to the city of Canterbury or to Dover, where further passage by boat could then be obtained across the Channel to France. During the 1840s, the sailing ships, or hoys, were replaced by steamships that began operating between Herne Bay and London. A type of vessel that was unique to Herne Bay was the Thanet Wherry, a narrow pulling boat about 5 m (18 ft) long, which was mainly used for fishing, but with the advent of tourism and the decline of fishing, they became mainly used for pleasure trips.

Herne Bay rose to prominence as a seaside resort during the 1830s when a group of London investors, in recognising Herne Bay's potential as a seaside resort, built a wooden pleasure pier and promenade. They intended renaming the town St Augustine's, but that name was unpopular with residents, so it remained Herne Bay. By 1834, steamboats were using the pier to land over 40,000 visitors each year. What had once been the haunt of smugglers and fishermen had grown into a fashionable Victorian resort with all the attendant features of bathing machines and assembly rooms. This, and the subsequent building of a railway station in 1861, led to the rapid expansion of the town's population of 1,232 in 1801 to 1,876 in 1831 and 3,041 in 1841. Today, the population is almost 36,000. It reached its heyday as a holiday destination in the late Victorian era, but its popularity has declined over the past decades with changes in holiday trends like the preference for overseas travel, which eventually caused the town's economy to decline after the 1960s.

Furthermore, the regular flooding of the Plenty Brook is another factor that has affected the town's redevelopment. In an effort to revive the resort, extensive seafront regeneration took place in the 1990s, creating the Neptune's Arm sea defence jetty, which in turn created a small harbour used by leisure boats, where tourists can take boat trips to a seal-watching site in the Thames Estuary. The Victorian gardens on the seafront were then fully restored, as was the Central Bandstand, originally built in 1924 after many years of disrepair and closure to the public. Today, Herne Bay is slowly regaining its popularity as a holiday resort and is a firm favourite with day trippers. It has become a firm favourite of mine.

Acknowledgements

I would like to extend my sincere thanks and gratitude to my wife, Pat Clancy, and Barry Kinnersley for supplying many of the modern-day pictures used in this book, and also Alan Dilnot, chairman of the Herne and Broomfield Local History Group, for his local knowledge. I would also like to thank Roy Moore, who allowed me to download a couple of pictures from his website kentphotoarchive.com, and Eric Hartland for his modern-day view.

The craze for sending picture postcards to friends and family a century ago and more has left us with a rich legacy of a window peering into everyday life as it was then. Every part of a postcard from the picture to the stamp, the postmark, the message it contains and the address is a reminder of a time gone by, and is a microcosm of our social history. Each one is locked in time, connected to the lives of two people – the sender and the recipient. Originally conceived as a means of sending tourist location images through the post, the publishers soon realised they also had a collectable potential and today collecting postcards, a hobby known as deltiology, has become big business, with collectors paying considerably more than the original purchase price for some 'cards, depending on their rarity. Most, however, can be bought for just a few pounds.

Every effort has been made to authenticate the information received from various sources, but sometimes time can play tricks on the memory. If any part of my text is inaccurate I sincerely apologise and will endeavour to correct it in any future editions of this book. Every reasonable effort has been made to trace and acknowledge the copyright holders of the pictures used herein, but should there be any errors or omissions, or people whom I could not contact, I will be pleased to insert the appropriate acknowledgement in any future editions.

John Clancy, BA (Hons), MA

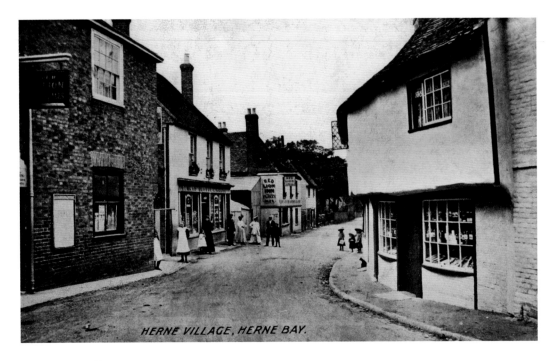

HERNE VILLAGE, HERNE BAY.

Herne Village

Herne, from which Herne Bay takes its name, is an ancient village separated from Herne Bay by the busy coastal road the Thanet Way, which marks the parish's northern boundary. Herne was once the first landfall along the coast from Reculver. The medieval street pattern is still apparent today, as can be seen in this view of the main street in the early 1900s. The centre of the village contains a wide variety of buildings dating from the fourteenth century to the present day, and includes thirty-one listed buildings, each giving the village a distinctive feel.

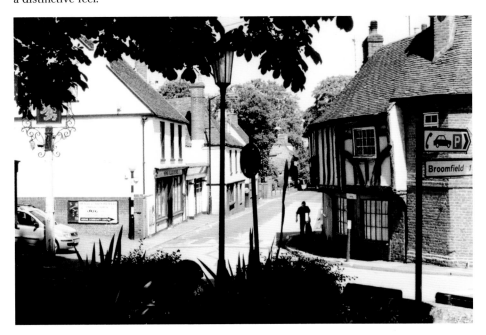

Herne Village.

Herne Village

The village grew slowly until the eighteenth century when there was an influx of wealthy families from Canterbury seeking a healthier lifestyle near the sea. Herne became affluent at that time as the nearby bay was an important outlet for trade to and from Canterbury and its hinterland. Herne also became the control point for goods passing through from the bay to the city. The village was the principal settlement and the parish of Herne extended all the way to the sea. Here in the upper view, postmarked 1906, it can be seen that the village had two pubs named somewhat unimaginatively the Upper Red Lion and the Lower Red Lion. Unimaginative or not, I bet there's a good story attached to the naming of these two pubs.

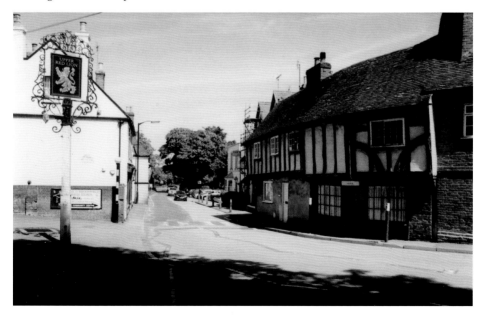

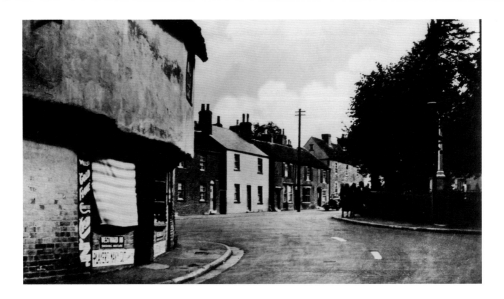

Herne Village

Herne Bay as such did not exist until the mid-1800s when the foundations for the town were laid as a result of a migration to the coast, and this is reflected in the population figures for Herne (and later Herne Bay). In 1801, Herne's population was 1,232. In the 1831 *Topographical Dictionary* Herne was described as 'a parish in the Hundred of Bleangate, lathe of St Augustine, county of Kent, 5¾ miles from Canterbury, containing 1,675 inhabitants'. In 1847, the population of the now detached Herne parish, including the hamlets of Eddington and Broomfield, was 1,469. By 1901 it had risen to 1,716. It increased massively sixty years later when it reached 4,576. Today, the population of the combined settlements of Herne and Broomfield has exploded to nearly 12,000. As the main road meanders through the village, we see the village shop referred to on this early postcard as the Smugglers' Cabin. It was originally part of a row of cottages known as Smugglers Cottages, some of which later became shops and one of which was a sweet shop known as Smugglers' Cabin. What tales could lie behind such a name?

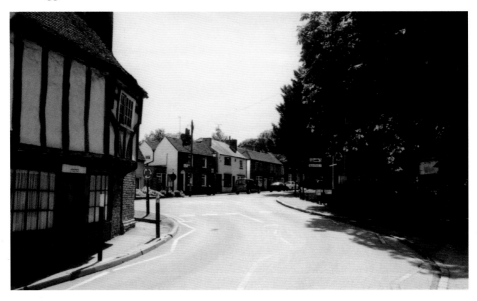

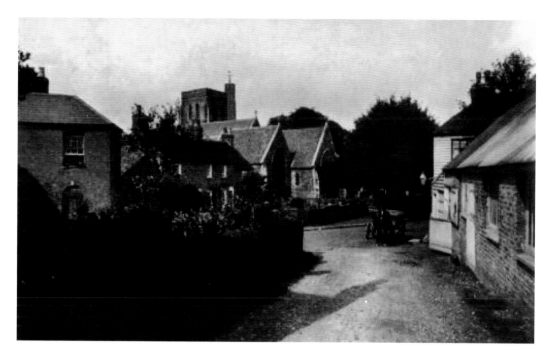

St Martin's Church

At the end of Albion Lane, as it joins the main road to Canterbury, stands Herne's fourteenth-century church dedicated to St Martin. It is described as being 'a large handsome structure consisting of three aisles and three chancels with a noble tower'. It is unquestionably a large, impressive, but relatively little-known church, and as such has been designated as a Grade 1 listed building. It can accommodate up to 1,000 worshippers.

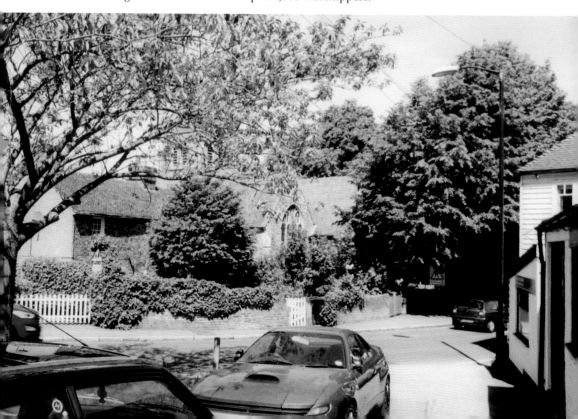

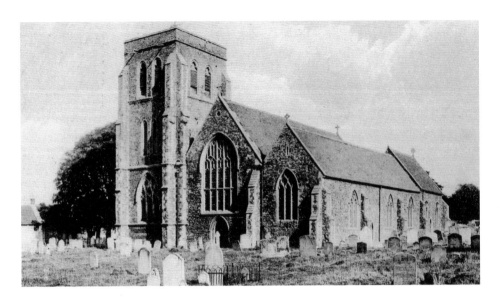

St Martin's Church

Extensive nineteenth-century restoration has left us with a church that displays little of its true history, but still contains much of interest. While the chancel screen, for example, dates from 1872, it offers a good comparison with the fourteenth-century screen of the north chapel which, unusually, has two east windows. The sedilia in the chancel takes the form of a series of three multi-cusped arches descending to the west, although the Victorian floor level makes nonsense of their height. There are some misericords incorporated into the Victorian stalls, and on the north chancel wall is an easter sepulchre, a memorial to Sir John Fyneux (*d.* 1525). The north chapel was once a chantry foundation with its own priest, and is connected to the chancel by a two-bay arcade and hagioscope. The rood loft stairway to the south of the chancel arch indicates that the screen did not run the full width of the church and that each of the chapel screens formed a separate construction. Seen here in 1907, it appears to have hardly changed in centuries, except for an increasing number of trees and bushes that attempt to hide this beautiful building.

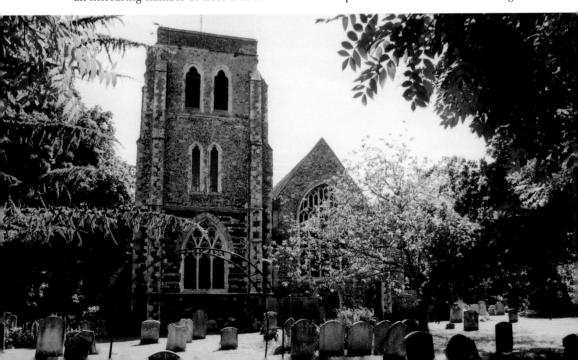

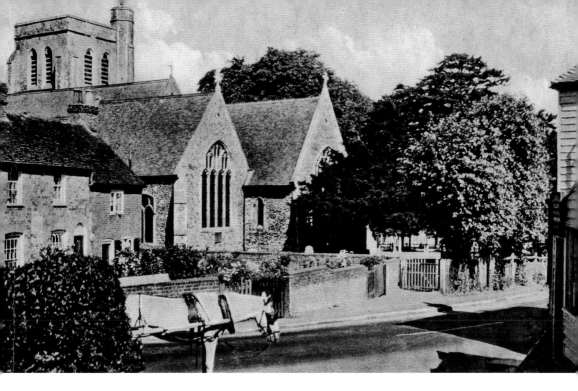

Another View of St Martin's Church
Always a popular topic for postcards, this one is postmarked 1909 and shows St Martin's church standing at the junction of Canterbury Road and Albion Lane.

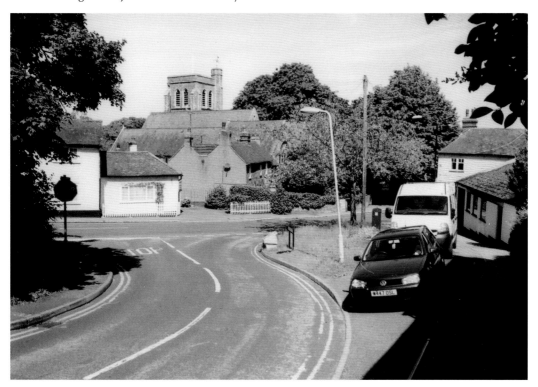

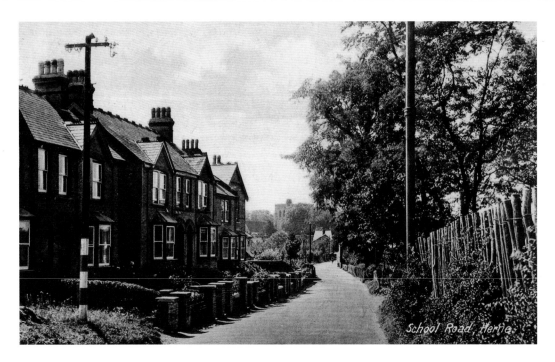

School Road

Hardly recognizable today as the same road, School Road, now known as School Lane, is a built-up area of modern houses. The church, seen at the end of the road in the early view, is now hidden by the trees, but the house in front of it can still be seen in the modern-day view. The terrace of Edwardian villas is now incorporated into the modern housing streetscape.

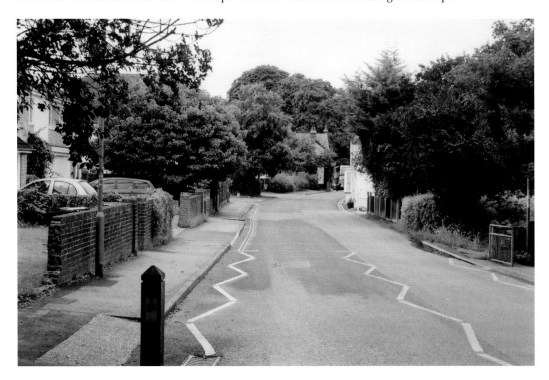

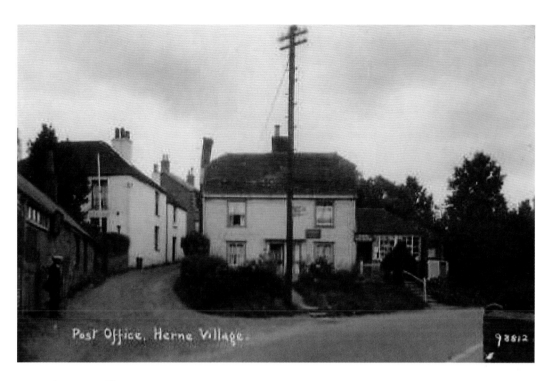

The Post Office

This turn-of-the-century view shows Herne's post office, a service that every town and village had at that time. As is often the case, over the years the trees and shrubs have grown considerably, blocking the *Through Time* photographer's view of the main subject – in this case the building. It is interesting to see how the road junction has been realigned at some point in time.

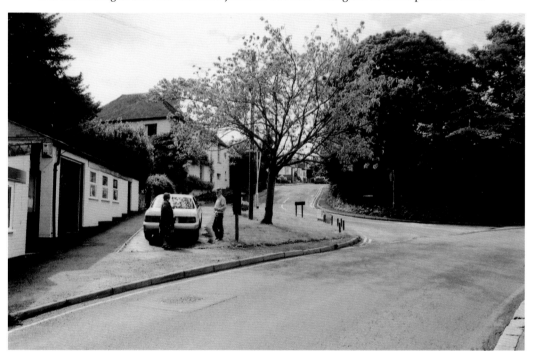

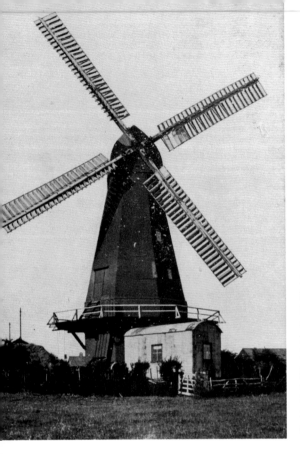

The Old Windmill

Herne's windmill is a three-storey Kentish Smock Mill built on a two-storey brick base in 1789. It is owned by Kent County Council and cared for by the volunteers of the Friends of Herne Mill. It is a Grade I listed building and is situated on high ground overlooking the village. The mill house next door is of a similar date. In 1856, the windmill's brick plinth had to be raised from its original single storey to two storeys to catch the wind. It ceased being a working mill in 1959, but the sails still turn and the former engine room now houses the parish office. Modern bungalows now surround the windmill, eroding much of its rural setting and obscuring views of it, all added to by a number of trees and bushes – a photographer's nightmare. The mill is looked after by a team of volunteers and is open to visitors on Sundays during the summer. There are spectacular views from the top.

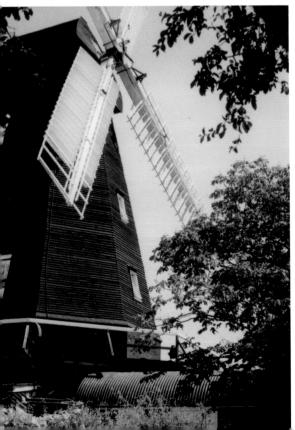

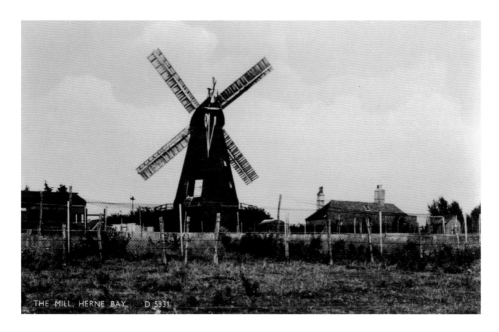

THE MILL, HERNE BAY D 5331

The Old Windmill

This is the latest in a long line of windmills that have occupied this site for centuries. Records show there was a windmill in Herne as early as 1405. It is a local landmark on the skyline above the village and can be clearly seen from the A299 Thanet Way, which passes nearby, as well as the surrounding countryside. Furthermore, it can also be seen by ships in the Thames Estuary where it is a recognized sea mark shown on nautical maps. This view is postmarked 1962 and looks very rural, but today, fifty-two years on, it is not so easy to get such a clear view of the windmill in its entirety due to a gradual urbanization of the village.

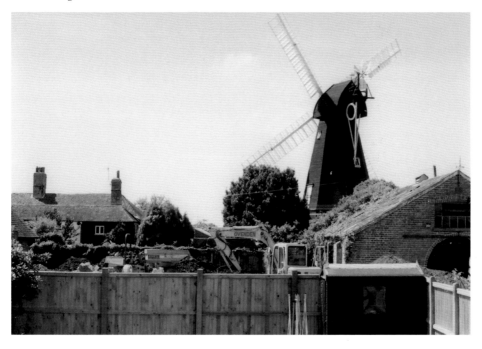

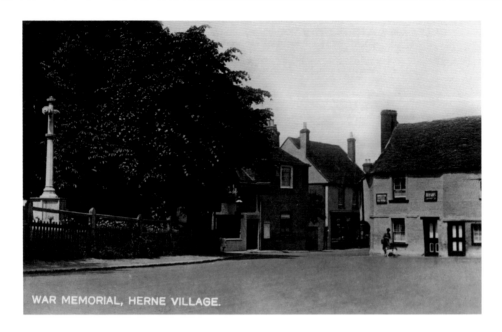

WAR MEMORIAL, HERNE VILLAGE.

Herne's War Memorial

The war memorial was constructed by Messrs Hart, Peard & Son of London and unveiled by Lord Harris of Belmont, Faversham. It was dedicated by the Revd Giles Daubeney, vicar of Herne on 29 June 1920. The money for it was raised by contributions from the people of Herne – the wealthy giving more and the poor giving just a few shillings (a lot to them). All the families of the sixty-six men on the memorial donated. Interestingly there is a soldier, Sgt Harry Wells, named on the memorial who won the VC. He was born in Hoath, which is in the parish of Herne. Herne and Broomfield Local History Group is currently working on a book, listing the names of all the village's men from the First World War.

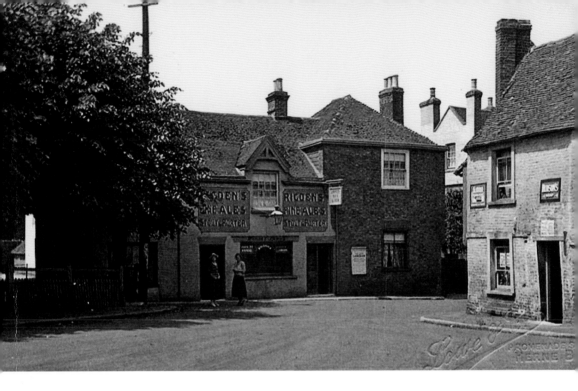

Herne Village Square
In a final look at Herne village, here is the village square as seen in the 1930s. Little seems to have changed since then, like much of the rest of this quiet corner of Kent.

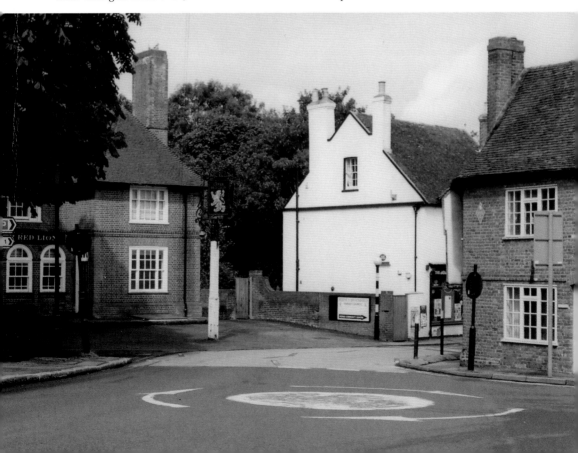

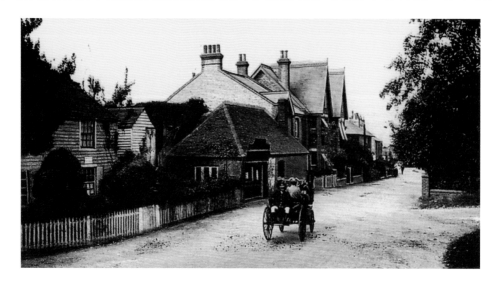

Eddington

Eddington was once a small hamlet situated south-east of Herne Bay and to the north of Herne. It is now a suburb of Herne Bay in the Greenhill and Eddington ward – one of five wards of Herne Bay. Until 2010 its main landmark for over 100 years was Herne Bay Court, a former school that was once renowned for having one of the largest and best-equipped school engineering workshops in England. It later became a Christian conference centre. This 1914 view was taken looking north from the Canterbury Road and Underdown Lane junction. The weatherboarded building in the foreground is the eighteenth-century Forge Cottage, and the brick building with large door and chimney was most likely once the forge. The tall building in the centre is Eddington Villas, built in 1896. Beyond the curve of the road ahead on the left would have been the spacious grounds of Eddington House, now the Beaumanor housing estate. Opposite Eddington House, on the right of the road in the distance, would have been the grounds of New College, now Herne Bay Court, which was built on the Parsonage farmstead site around 1900.

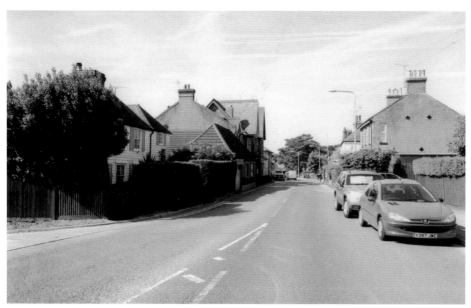

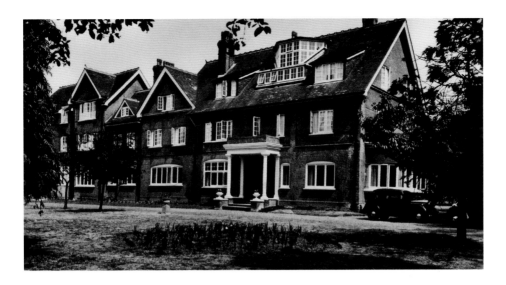

Herne Bay Court

Herne Bay Court, near Talmead, was a local landmark from 1900 to 2008. In 1900, James Thurman MA bought part of Parsonage Farm at Eddington from Joseph Gore and built New College on the site – known locally as Eddington College. It was a school in competition with Herne Bay College, which at that time occupied Nos 6–8 St George's Terrace, Herne Bay. It was run by Capt. Eustace Turner. Both schools were evacuated in the First World War, and were requisitioned by the military. Thurman retired and, after the war, Eddington College was taken over by Capt. Turner who ran it as Herne Bay College until 1939. The college specialised in engineering and, in the 1930s, it possessed one of the largest and best-equipped school engineering workshops in England. It was renowned for its many engineering examination successes. The building and its engineering equipment were requisitioned for the Second World War effort, but after the loss of its engineering equipment the school could not reopen after the war and the building was sold. It reopened in 1949 as Herne Bay Court, a Christian conference centre. By 2006 it had closed and was standing empty for several years. Between 2007 and 2010 there was a local campaign to save or reopen Herne Bay Court. This building is locally listed as army headquarters in the Second World War.

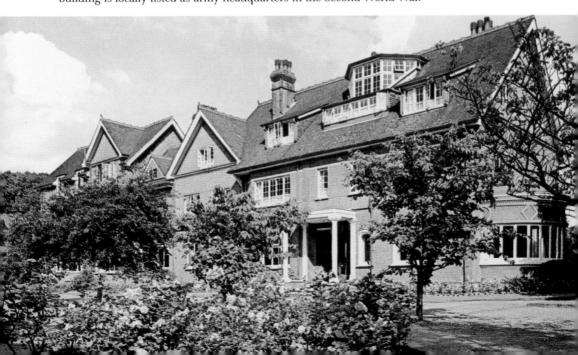

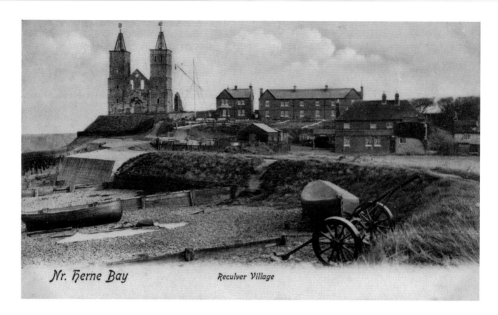

Nr. Herne Bay *Reculver Village*

Herne Bay's Twin Towers

Standing 3 miles to the east of Herne Bay are the distinctive twin towers of St Mary's church, Reculver. It is a landmark that can clearly be seen from land and sea from many miles away. Reculver once occupied a strategic location at the north-western end of the Wantsum Channel, a sea lane which separated the Isle of Thanet from the Kent mainland until the late Middle Ages. This led the Romans to build a small fort here at the time of their conquest of Britain in AD 43. Starting late in the second century, they built a larger fort which later became part of the chain of Saxon shore forts. After the Romans left Britain early in the fifth century, Reculver became a landed estate of the Anglo Saxon kings of Kent and the site of the Roman fort was given over for the establishment of a monastery dedicated to St Mary in AD 669. This 1903 view shows the village still quite intact, compared with the modern-day view in which the only original building left is the inn – the former vicarage. Where once there was a thriving town, there is now a car park, and the beach, seen in the top picture, is now hidden from view behind a massive sea wall.

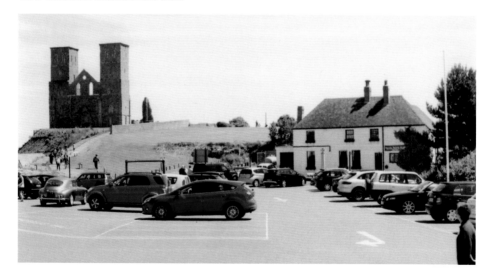

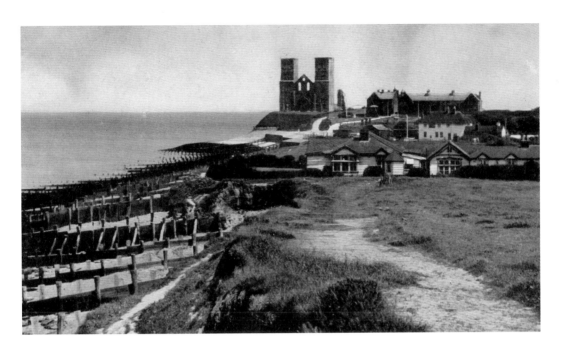

Reculver

During the Middle Ages, Reculver was a thriving small town with a weekly market and an annual fair. It was also a member of the Cinque Ports confederation. The twin spires of the church became a landmark, known as the Twin Sisters, for mariners, and the nineteenth-century façade of St John's Cathedral in Sydney, Australia, is a copy of that at Reculver. Reculver declined as the Wantsum Channel silted up, and coastal erosion claimed many buildings constructed on the soft sandy cliffs. The village was largely abandoned in the late eighteenth century, and most of the church was demolished in the early nineteenth century. Protecting the ruins and the rest of Reculver from erosion is an ongoing challenge. Compared to the previous view, this undated view shows how the twin towers have now lost their spires.

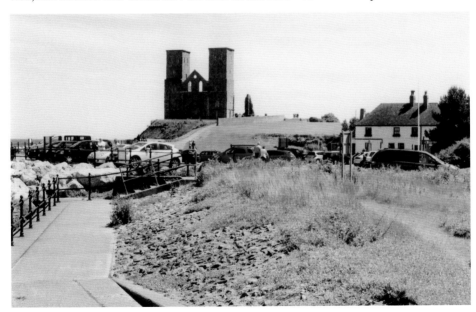

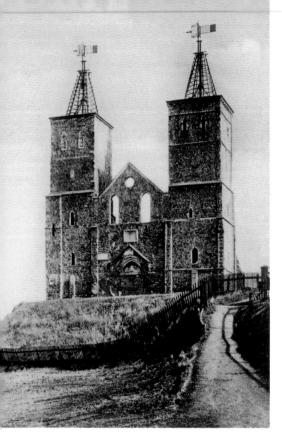

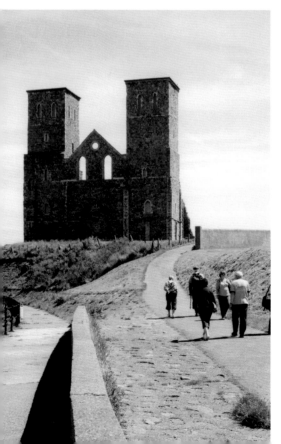

St Mary's Church, Reculver

The westward facing, front façade of the ruined church. By March 1809, erosion of the cliff had brought its edge to within 12 ft (4 m) of the church, and demolition began in September that year. Trinity House intervened to ensure that the towers were preserved as a navigational aid and, in 1810, bought what was left of the structure for £100. They built the first groynes designed to protect the cliff on which the ruined church stands. Today, the site of the church is managed by English Heritage and the village of Reculver has all but disappeared. The present appearance of the cliff below the church, a grassy slope above a large stone groyne, was in place by April 1867. The sea defences there continue to be maintained by Trinity House.

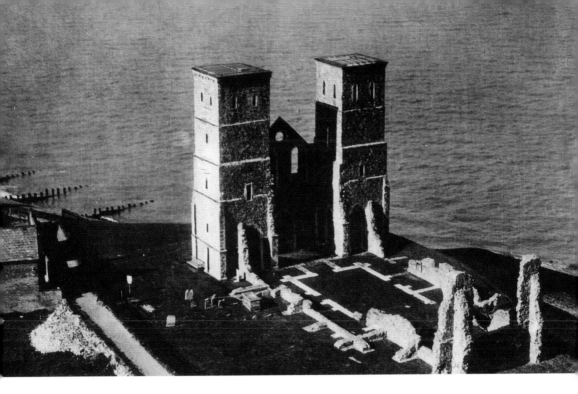

Reculver from the Air

Two aerial views above Reculver. Whereas the top picture clearly shows the layout of the ruined church, its twin towers still standing defiantly against the ever-crumbling cliff, the lower picture, taken in the 1950s, is looking westwards over the caravan park to Herne Bay in the distance.

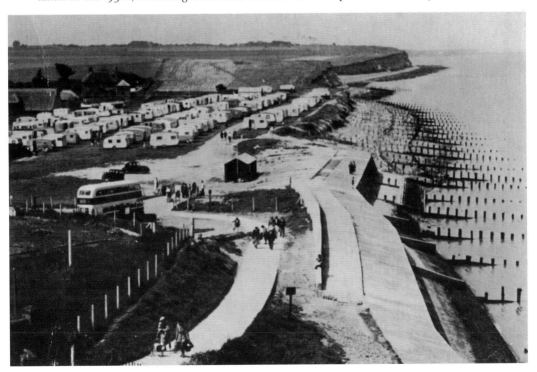

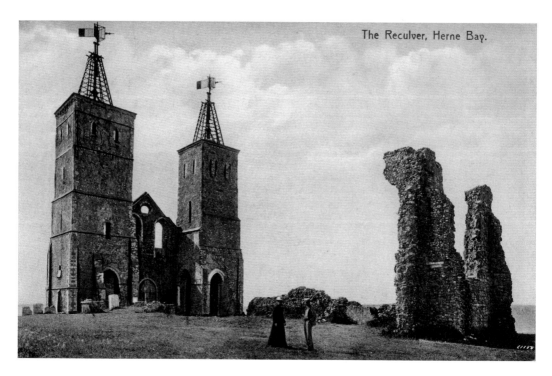

The Reculver, Herne Bay.

A Church of Some Size

For such a small village, St Mary's church was once quite a substantial building – as can be seen in this view from the early 1900s in which two Edwardian visitors give a scale from which to judge.

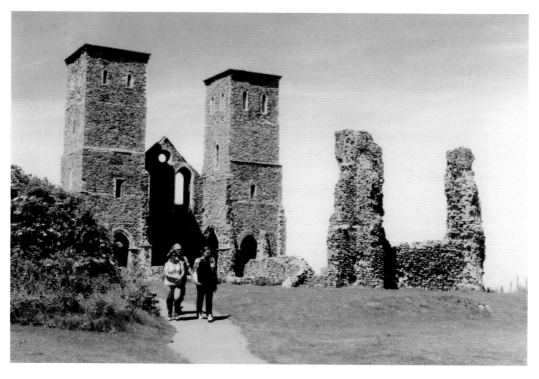

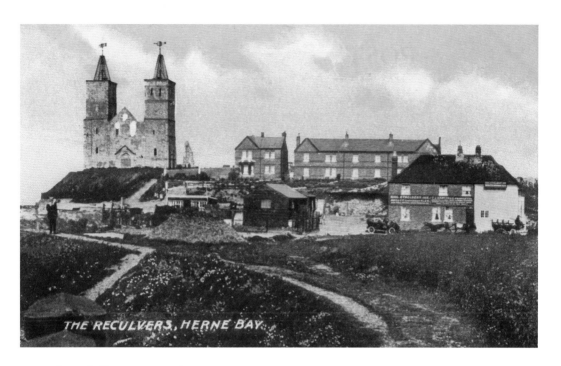

THE RECULVERS, HERNE BAY

King Ethelbert Inn, Reculver

When Reculver's original inn, the Hoy and Anchor, fell into the sea sometime before 1800, the redundant vicarage became a temporary replacement under the same name. Despite there being only five or six houses left at Reculver in 1800, a new Hoy and Anchor Inn was built by 1809 and renamed the King Ethelbert Inn in the 1830s. Further construction work is indicated by a stone over the doorway to the inn bearing a date of 1843. It was later extended into the form in which it stands today – probably in 1883.

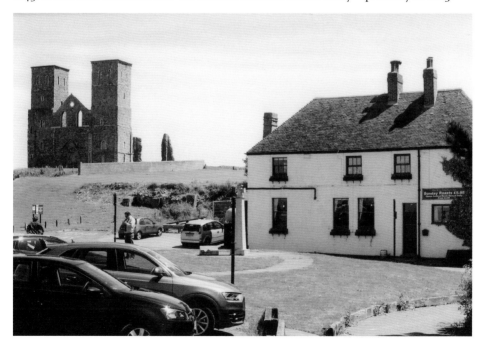

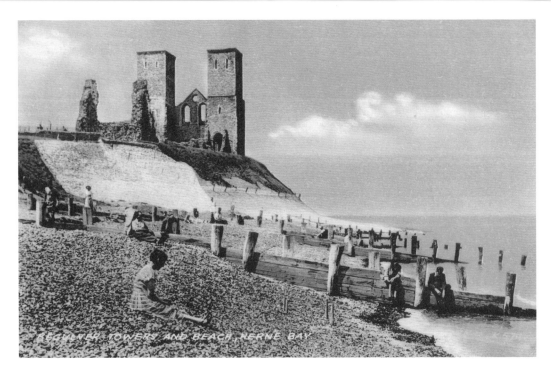

RECULVER TOWERS AND BEACH, HERNE BAY

Reculver Beach

As well as the church ruins and traces of the former Roman fort to explore, the far eastern side of Reculver has a popular beach that today is probably a Mecca for treasure hunters and metal detectorists given the amount of ongoing coastal erosion that is taking place here.

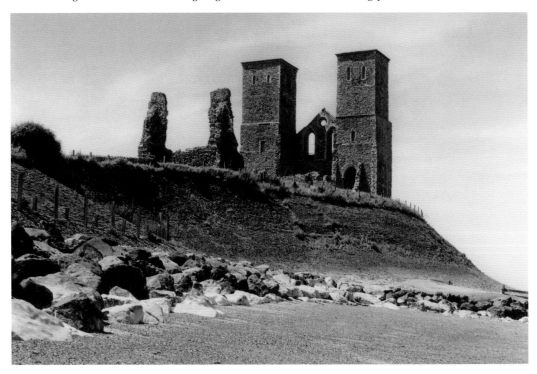

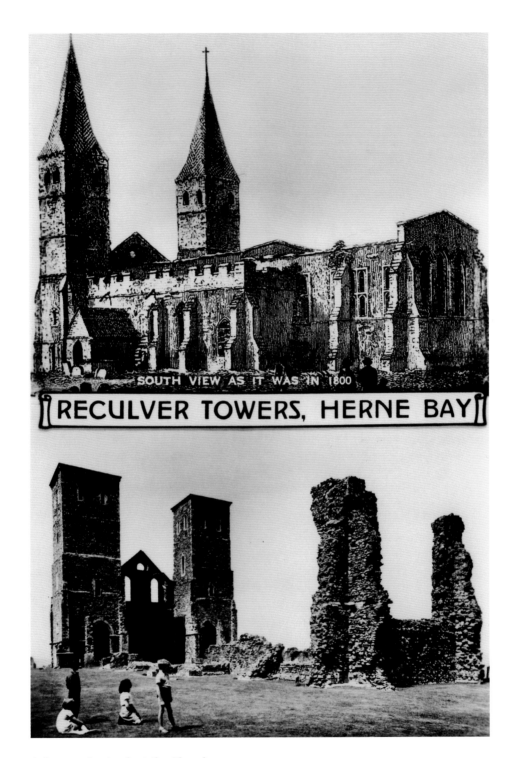

SOUTH VIEW AS IT WAS IN 1800

RECULVER TOWERS, HERNE BAY

A Contrasting Look at the Church

Only 150 years separates these two views of St Mary's church, but what a transformation has taken place. In 1800, the church was relatively intact. Only the main roof appears to have gone. Very little remained from around 1958 onwards.

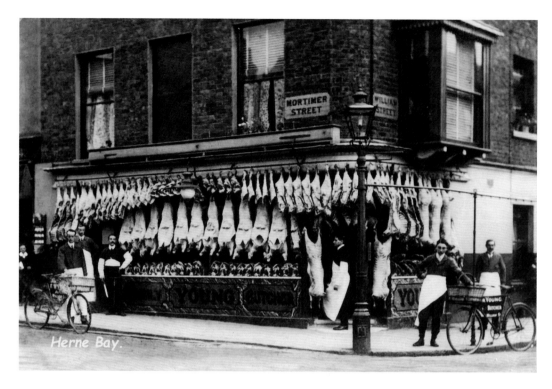

How a Butcher's Shop Used to Look

Long ago, butchers would hang their meat outside their shop for all to see, but it was also an attraction for flies and pollution. How very different it is to today's shops where scrupulous cleanliness is the order of the day. Here we see Young's two delivery boys, bicycles at the ready, all set for another home delivery. Standing on the corner of Mortimer Street and William Street, this shop is now the Valkyrie tapas bar.

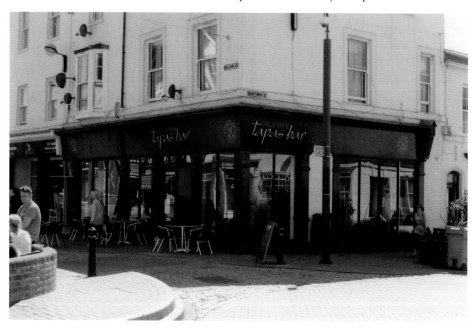

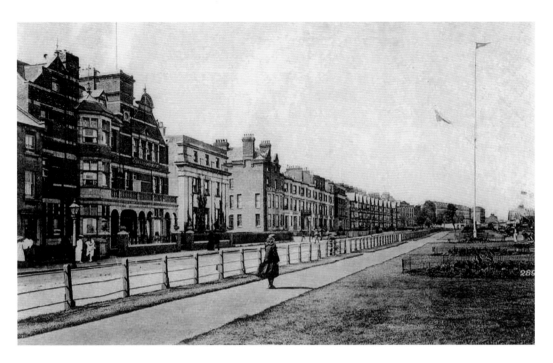

The Connaught Hotel

Overlooking the Tower Gardens, the Connaught was once one of Herne Bay's top hotels and restaurants, but in 1985 it became the Connaught Bingo Club, a small but friendly club with seating for 200.

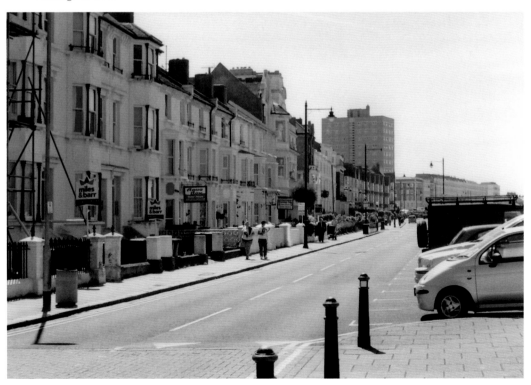

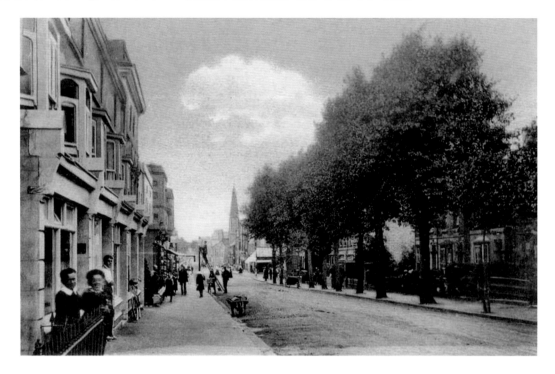

The High Street

Looking westwards down the High Street towards the church that stands on the corner of Beach Street. It appears that the early photographer, with his huge camera on a tripod, was a source of amusement and wonderment to these small boys. Today, I hardly warranted a second glance with my tiny digital camera. How very different the road looks today with its trees gone and its houses, for the most part, turned into shops. The church spire, however, remains, serving as a useful reference point.

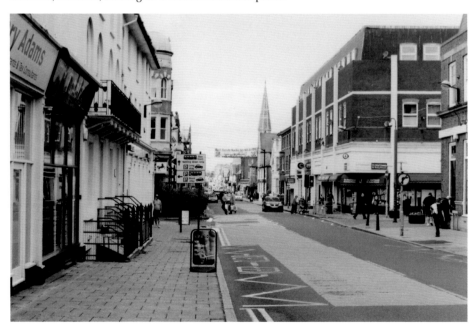

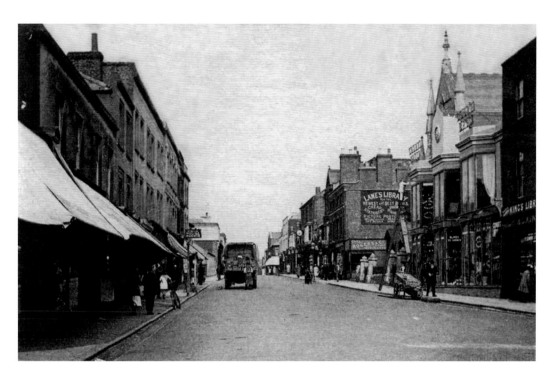

Mortimer Street

Herne Bay must have been quite an intellectual place when this picture was taken. On the right-hand side can clearly be seen two libraries – Lane's and King's. The building to the left of King's library is distinctive with its pointed finials, but today no trace of it remains, making it difficult to locate the whereabouts of these libraries. However, in the modern-day view, the KCC library is just discernable to the right.

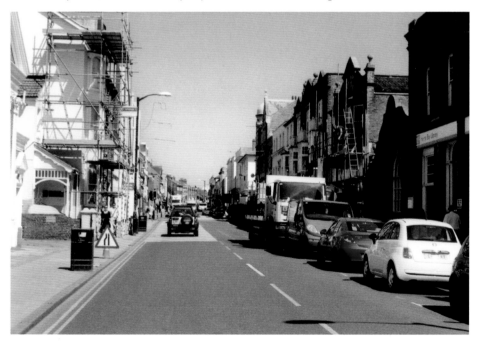

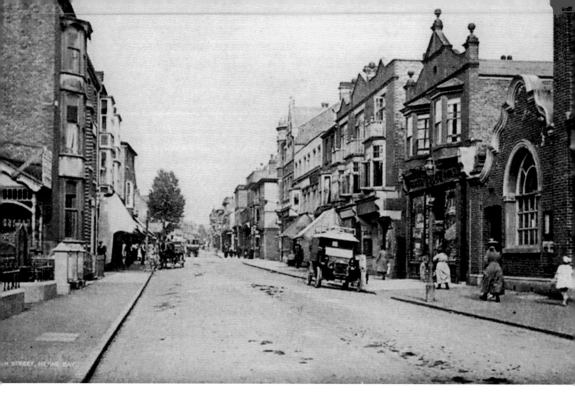

The High Street
A typical High Street, but not quite as bustling as it is today.

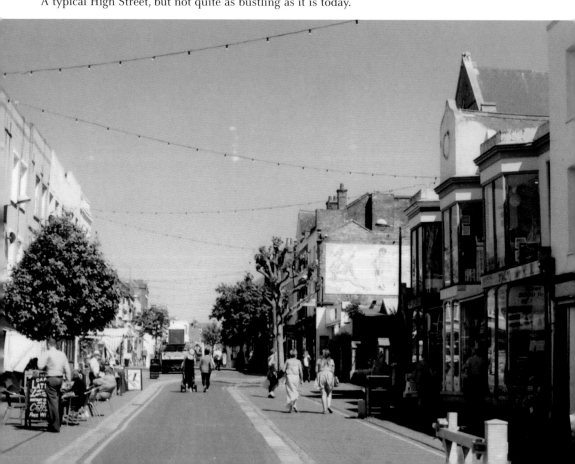

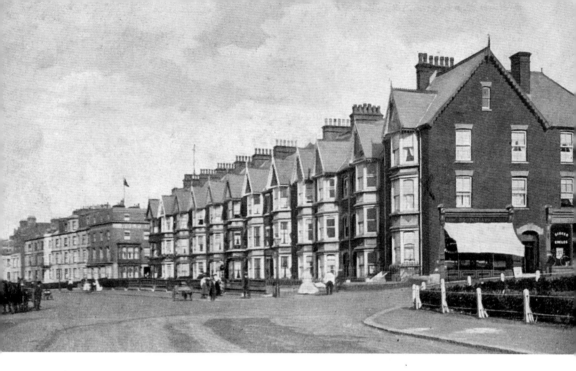

Marina Crescent
Taken around 1917, this terrace of modest guest houses overlooks the entrance to the pier and has remained unchanged over the years.

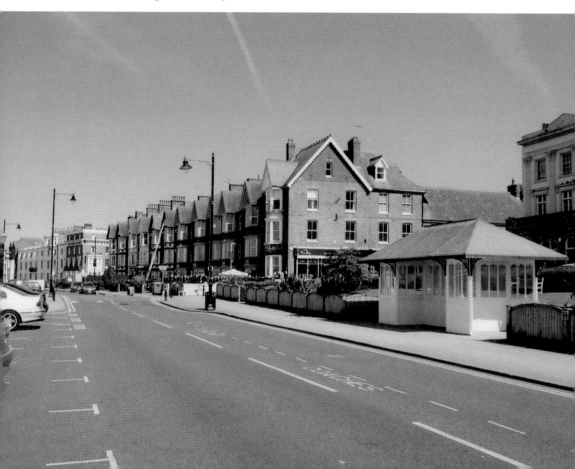

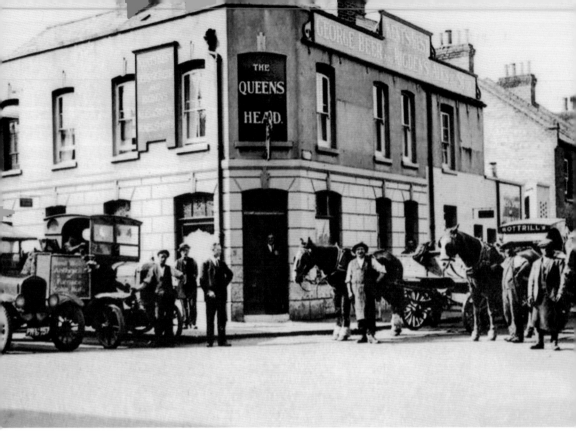

The Queen's Head
Situated in William Street, this picture takes us back to the early 1900s.

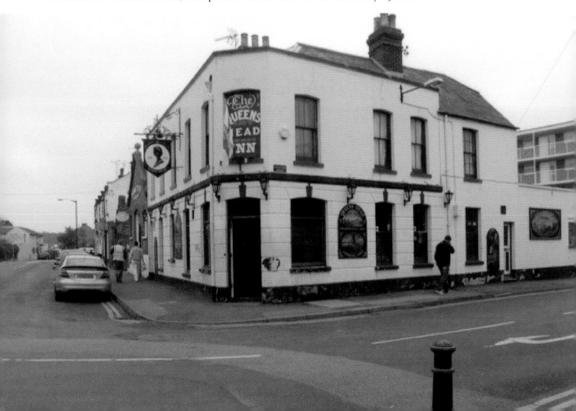

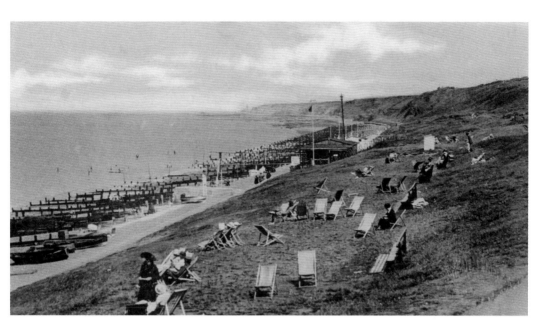

The Downs, Looking Eastwards

For those who seek an alternative to sitting on the beach, the clifftops to the east, known as The Downs, offers a popular change, as can be seen in this Edwardian view of the early 1900s. The twin towers of Reculver can be seen further along the coast. In 1800 during the Napoleonic War, a battery of guns and a squadron of mounted troops were stationed here. Today, the once grassy slope has become overgrown due to a lack of sun worshippers using it.

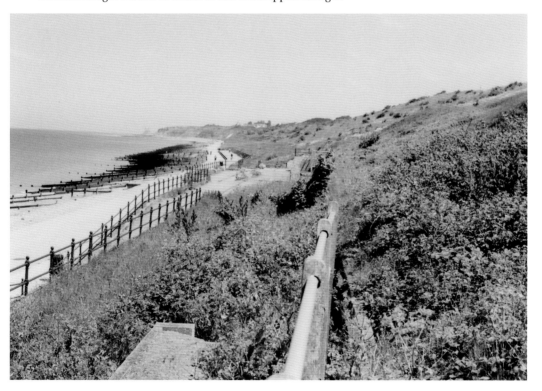

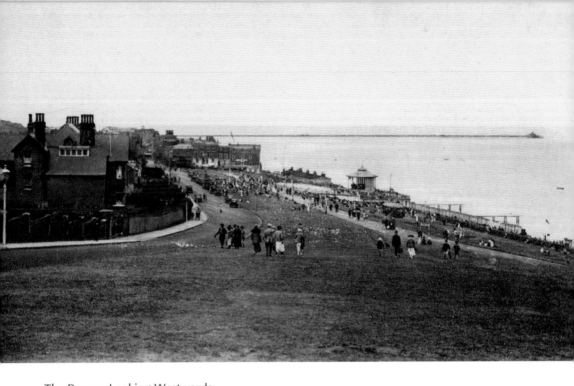

The Downs, Looking Westwards
Looking back towards the town from The Downs. In the background can clearly be seen the pier. Today, only the pier head remains far out to sea looking more like a wrecked ship.

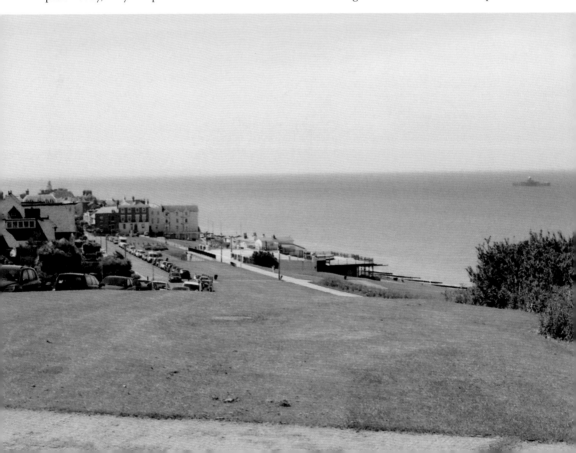

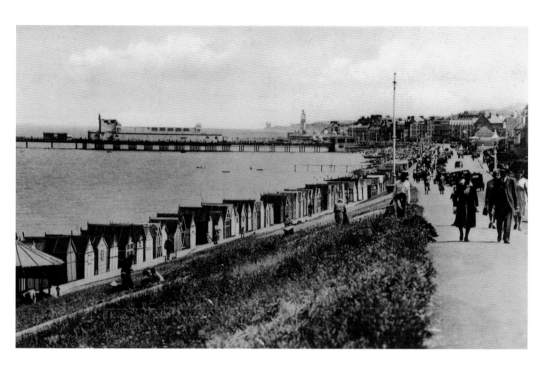

West Promenade

To the west of the pier is West Promenade, which takes you to the long-gone village of Hampton-on-Sea – another casualty of coastal erosion. Even though this postcard is franked with the date 19 August 1953, I suspect this picture was taken much earlier. Today, the beach huts have gone, but the sea views from the grassy slope remain.

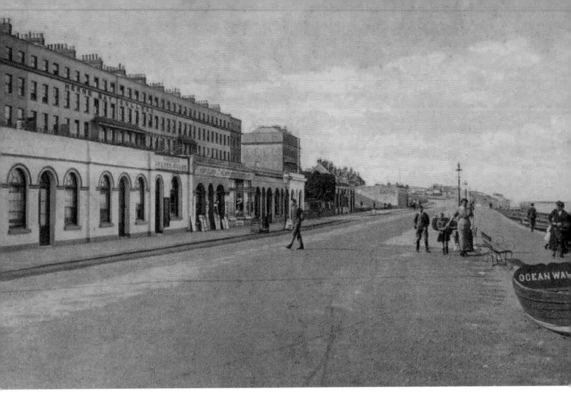

The Parade Looking Towards West Cliff
Once part of a seafront bar or public house, this particular building is now an amusement arcade that overlooks the popular west beach.

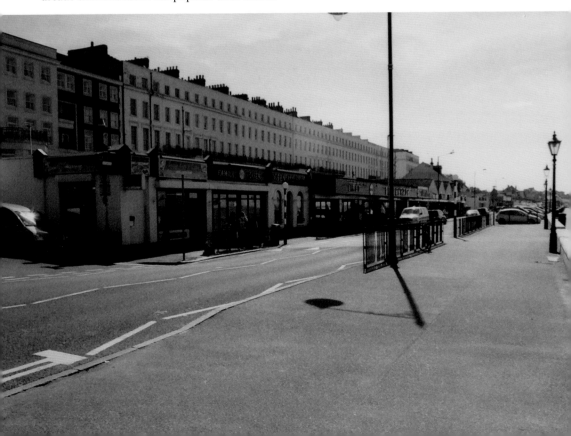

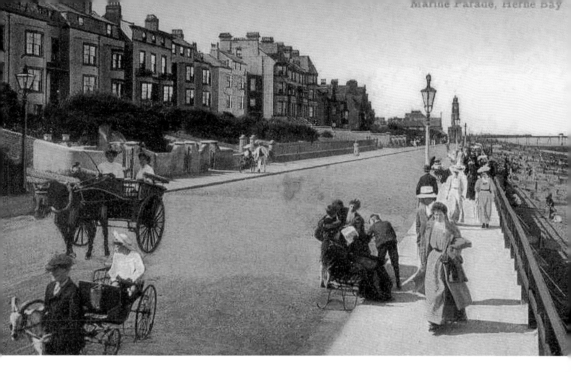

Marine Parade

Stretching away to the east of the main seafront is Marine Parade. In the background of this late Victorian, hand-tinted view can clearly be seen the Clock Tower and the pier. I particularly like the goat-drawn carriage in the bottom left corner.

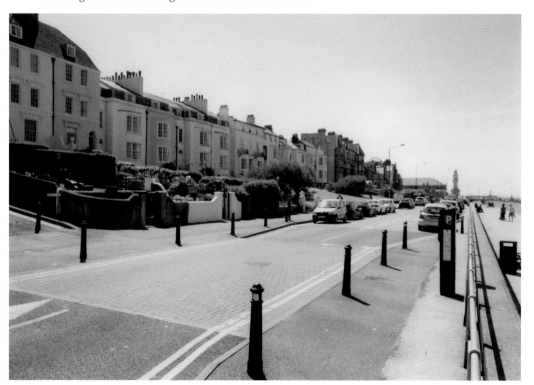

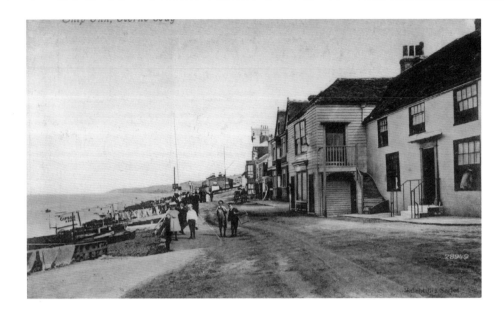

The Ship Inn

One of the oldest buildings in Herne Bay is the late eighteenth-century Ship Inn, which was the focal point for the small shipping and farming community that first inhabited the town. The inn stands where the road from Canterbury reaches the seashore, so it was here that wagons loaded with farm produce and went down to the beach at low tide to load their produce on to hoys (a type of barge) for transport to the Medway towns and London. These boats would then return with cinders and small pieces of coal and ash left from the production of bricks, as well as the dung from the London stables to fertilize the surrounding farm fields. The Ship was an essential watering place for the men employed in these trades because water was generally unsafe to drink. By 1800, when the whole country was under the threat of a Napoleonic invasion, a battery of guns and a squadron of mounted troops were stationed on The Downs, and to provide a place of entertainment for these men, a weather boarded assembly room was added to the inn.

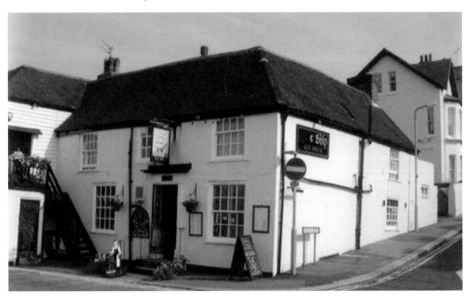

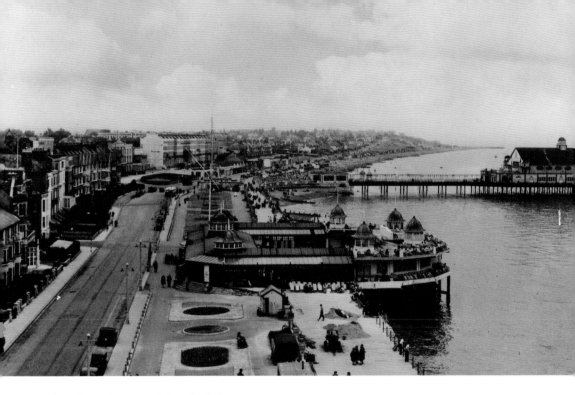

View from the Top of the Clock Tower

A prominent seafront structure is the Clock Tower, which was built in 1837. It is a Grade II listed landmark and is believed to be one of the earliest purpose-built, free-standing clock towers in the UK. Although not open to the public, this is the expansive seafront view you get from the top of it.

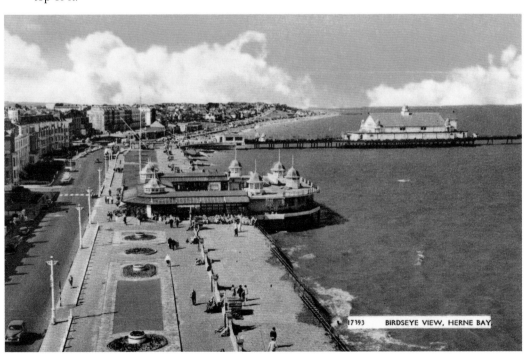

17393 BIRDSEYE VIEW, HERNE BAY

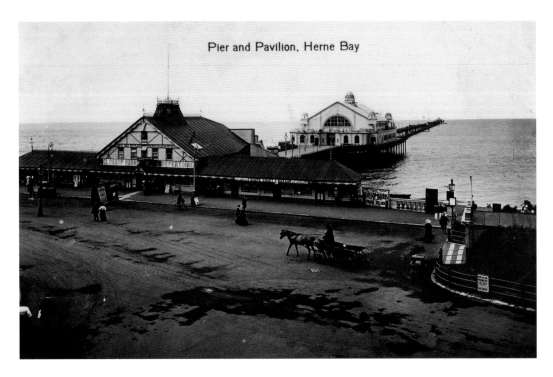

Pier and Pavilion, Herne Bay

The Third Pier

The pier we see today is but a shadow of its former self. It is the third pier to be built here, and the gap between the landward end and the pier head far out to sea is the result of a storm that occurred in 1978. Further demolition work took place in 1980, leaving just the short section upon which a sports hall stood. That itself was demolished in 2012, leaving an open space where temporary entertainment activities take place.

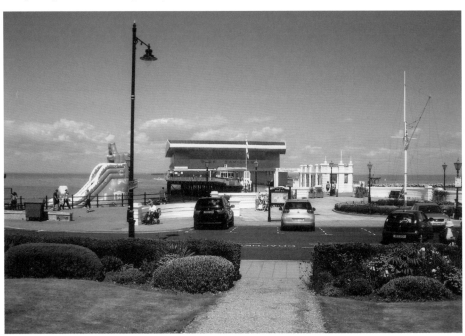

The Pier Pavilion

In 1871, the Herne Bay Improvement Commissioners purchased the original pier, demolished it, and in its place built pier number two. Unfortunately it was too short for the visiting paddle steamers to tie up to, but it was deemed to be long enough for promenading and entertainment; it had a bandstand at the pier head. Although the new pier authority, Herne Bay Pavilion Pier & Promenade Co., also built a wooden theatre, shops, lavatories and ticket office across its entrance in June 1884, it made no money. The theatre was known as the pavilion and was designed by McIntyre North. In response to popular demand, the pier company applied to parliament in 1890 for powers to construct a deep-sea pier, which was granted in 1891. A new restaurant, built in 1899 at the pier head, later became a ticket office and cafe, and still stands today – wooden, octagonal and domed with a promenade deck on the roof. In February 1904, the managing director of the pier company and treasurer of Holborn Borough Council, Henry C. Jones, was arrested for embezzling funds from the council to use for the pier. The company went into receivership and the pier was offered to Herne Bay Urban District Council for £6,000. The council considered the old Pavilion Theatre at the pier entrance too small, so in 1910 organised a competition to design a new grand pier pavilion. Percy Waldram, Mr Moscrop-Young and Mr Glanfield of London won it and, in May to June of that year, the marquee section was widened and the new pavilion built for £2,000. It seated 1,000 and its auditorium was 130 × 95 × 35 feet high, with stage and dressing rooms. It had a rock maple, multi-purpose floor for roller skating, dancing, public events and community activities. On 9 September 1928 the theatre, shops and Mazzoleni's cafe at the entrance were destroyed by fire but the Grand Pavilion survived.

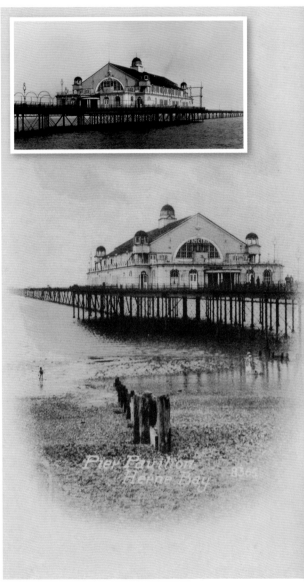

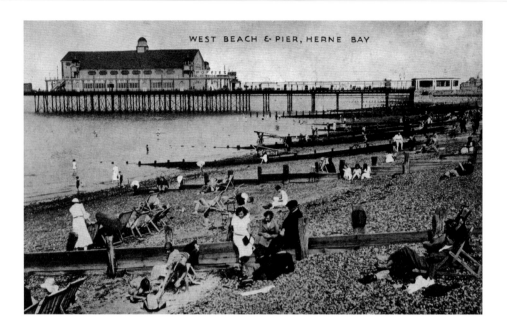

WEST BEACH & PIER, HERNE BAY

The Pier Pavilion in Later Years

By 1968 the pier head had been closed and abandoned. Insurance cover for much of the pier beyond the pavilion was withdrawn and the public were excluded. The Pavilion was then refurbished at a cost of £158,000, but was destroyed by fire, possibly caused by a spark from a welding torch during pier entrance reconstruction work in June 1970. A new pier pavilion was then designed by John C. Clague in 1971 and opened by the Rt Hon. Edward Heath on 5 September 1976. The new building lacked any architectural merit, and the locals referred to it as The Cowshed. However, despite their contempt for it, each of the three pavilions had had roller hockey rinks, and it is from here the sport developed to become a worldwide activity. The Herne Bay Rink is known throughout the roller hockey world as 'the home of roller hockey'.

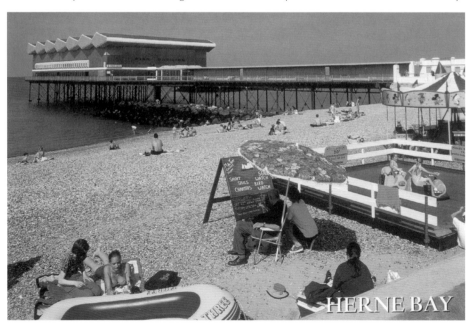

HERNE BAY

Demolition of the Pavilion

In the spring of 2009 Canterbury City Council agreed to the formation of the Herne Bay Pier Trust, whose remit was to preserve, renovate, reconstruct and enhance what was left of the pier. The first stage of the improvement works was the closure and demolition of the pavilion in 2011. A tarmac hard standing was put down in its place, with benches surrounding it, making it somewhere the public can freely walk, play, and enjoy panoramic views of the estuary and the old pier head. It is well suited to being a performance area. Another new innovation was the creation of the Retail Village on the pier, a collection of, essentially, beach huts, which was opened by TV personality Sandi Toksvig and Cllr Ann Taylor, Sheriff of Canterbury, on Saturday 6 July 2013. When forming the village, the trustees looked for quality, retro, quirky and the unusual so that residents and visitors could have a different experience while avoiding unnecessary competition between each hut and the town traders. Twelve retail huts have so far been built with planning permission having been obtained for six more.

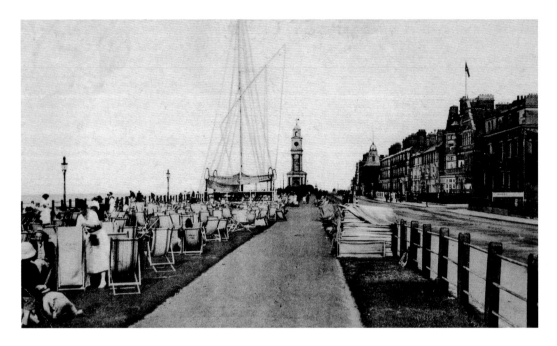

Tower Gardens

Even though Herne Bay had acquired a pier and had become popular with day trippers by 1832, its formal seafront promenade did not come into being until much later. What had once been the haunt of fishermen and smugglers slowly grew into a fashionable Victorian resort. It was not until the early 1920s that the grassy strip of coastline started to be developed into a delightful, paved promenade with flower beds.

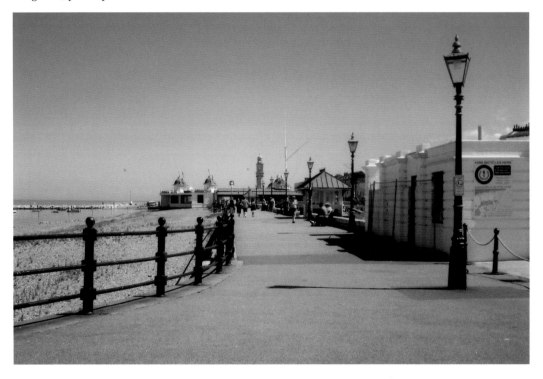

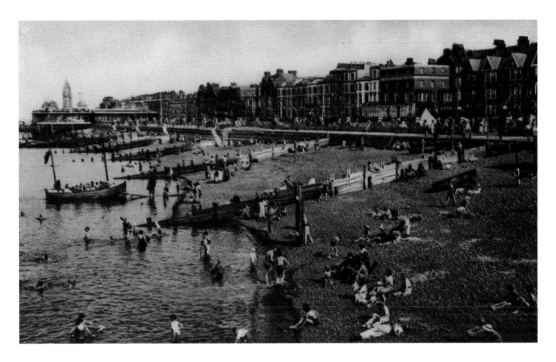

A Changing Beachscape

How very different the beach looks from the pier in these two views. The top one was taken in the 1930s, while below is how it looks today. Part of the reason why this stretch of the beach is now so deserted is because it looks out on to the sea defence jetty Neptune's Arm, rather than the open sea. Instead, sun worshippers flock to the open beach to the west of the pier.

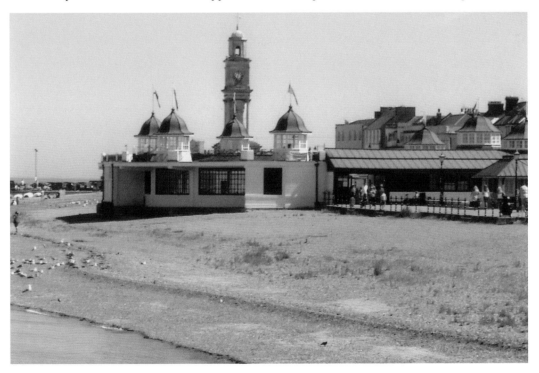

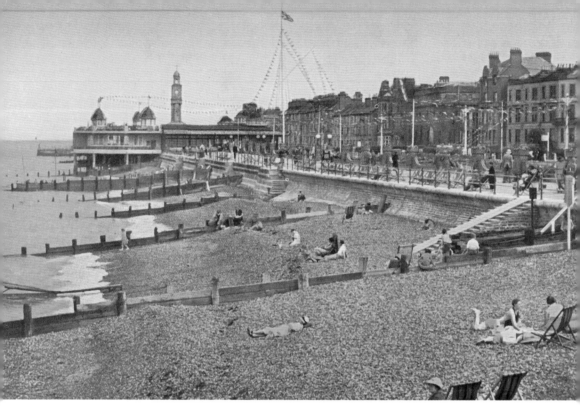

The Beach
A hand-tinted view of the beach of an unknown date, looking eastwards from the pier to the bandstand.

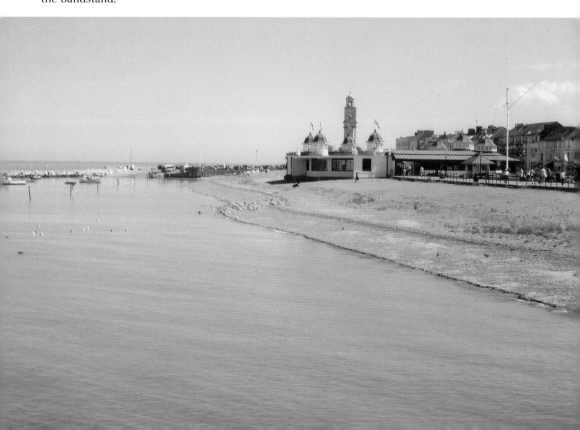

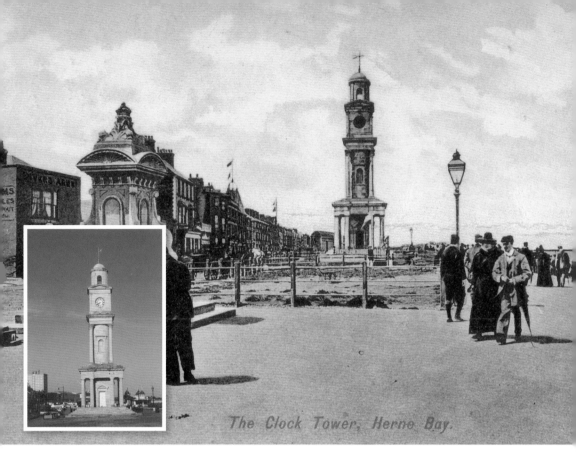

The Clock Tower, Herne Bay.

The Clock Tower

Dominating the seafront promenade is the Clock Tower, an 82-foot Grade II listed structure that was gifted to the town in October 1837 by Mrs Ann Thwaytes, the rich widow of a London grocer who regularly visited the town. It is without doubt Herne Bay's most striking architectural feature. Costing £4,000, it is believed to be one of the earliest purpose-built, free-standing clock towers in the UK. Herne Bay historian Mike Bundock suggests a possible inspiration for the unusual design of this tower is that on the back of No. 31 Marine Terrace, next door to Mrs Thwaytes' holiday residence, was a Royal Exchange Assurance Co. lead fire-mark badge bearing a picture of the Royal Exchange tower. Mrs Thwaytes was already familiar with the Royal Exchange tower, as she had lived close to it during her marriage, so in 1836, possibly inspired by the success of the nearby pier and the grandeur of this image, she requested the young architect Edwin James Dangerfield of London and Herne Bay to draw a plan of a tower in the style of a Grecian temple with a clock at the top. Many seaside resorts throughout the UK have a seafront clock, an important public amenity, reminding people of the time so that they did not miss meal times at their hotel or guest house, their train or steamer home etc. Remember, this was a time long before the invention of the wristwatch, and few would have been able to afford a pocket watch.

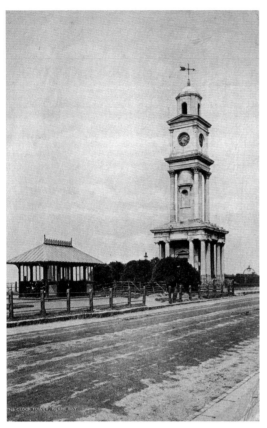

The Clock Tower

The Clock Tower in 1921. Sometime after 1900 two cannons were placed on the north-east and north-west corners of the steps. They are possibly Dutch in origin and were found on the seabed on 11 January and 10 April 1899 during the construction of the third pier. They were used to fire blanks as a fog warning, and had originally been mounted on the first pier until 1862. New carriages and brass plates dating the recovery were made for them and they stood outside the old Pier Theatre but were later moved to the base of the Clock Tower. A plaque, dedicated to the thirty-six fallen Herne Bay volunteers of the Second Boer War was affixed shortly after 1902 to the tower's north side.

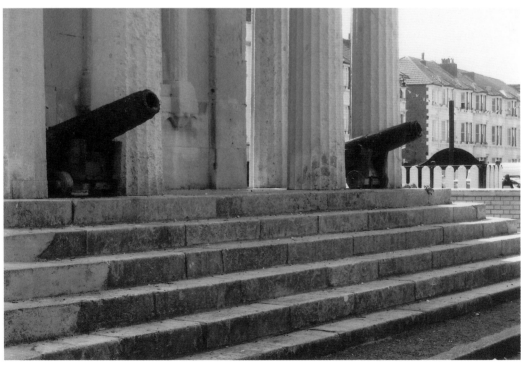

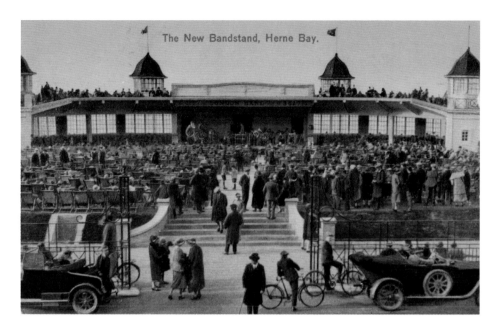

The New Bandstand, Herne Bay.

The Bandstand

An essential seaside amenity for the Victorian and Edwardian holidaymakers was a bandstand where they could enjoy not only their favourite brass bands, but many other forms of entertainment as well. It was first called the New Bandstand, and then the Central Bandstand to differentiate it from other bandstands in Herne Bay, especially that which stood on the roof of the King's Hall and has since been demolished. Built in 1924, to begin with, as can be seen above in this view in 1931, it consisted only of the crescent shaped, three-sided building that still is the stage area. The southern side was open to the elements and the road, and passing motorists were asked not to sound their horns if a performance was taking place. Screens were available to protect the public from the wind blowing in from the east or the west. The roof was used as a sundeck, while below was a promenade deck overlooking the sea. The bandstand was a popular venue for visiting military band concerts, and in the 1920s and 1930s a red carpet would be laid across the road and up to the stage for the conductor of the brass band to walk from the Connaught Hotel, which was directly opposite the Bandstand.

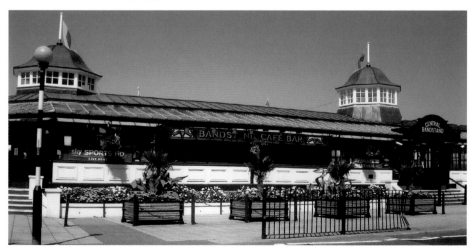

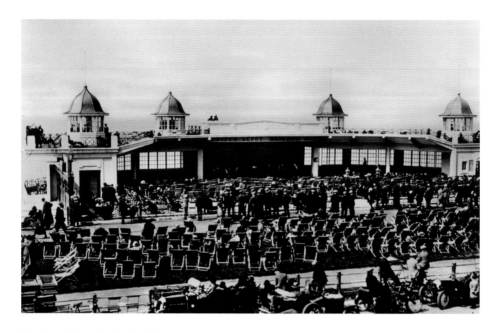

The Bandstand in Later Years

In 1932, the Art Deco frontage abutting on to the road, which is today used as a café, was added, thus enclosing the entire building. Glazed roofing panels were added to the side sections, but the centre was left open to the sky. It became a popular venue for afternoon tea dances with live bands, and continued to be so up to the outbreak of the Second World War. Following the end of the war the bandstand quickly regained its pre-war popularity and continued to be enjoyed by holidaymakers, day trippers and locals alike, until the 1980s when it started falling into a state of disrepair. It was restored to its former glory in 1999 when the copper domes and glazed ironworks were added. Sadly, today's modern street furniture, railings and pedestrian crossing mar the frontage of a fine, old building.

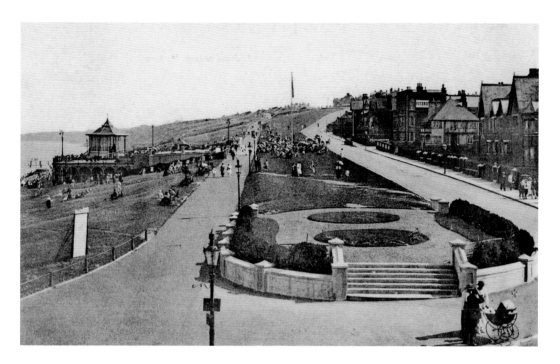

The Downs and East Cliff

Should visitors to Herne Bay tire of the beach or promenade, then a brisk coastal clifftop walk can be taken along The Downs, a grassy slope on the East Cliff, heading towards Reculver with its landmark ruined church. Fifty years separates these two pictures, the top one being taken in 1931 and the lower one in 1982. During the Napoleonic Wars, this had been a gun site and military camp. Walkers could stop awhile at the small bandstand en route – the East Cliff Pavilion – seen in the top picture.

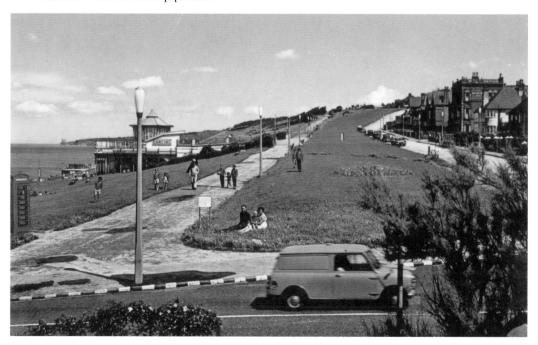

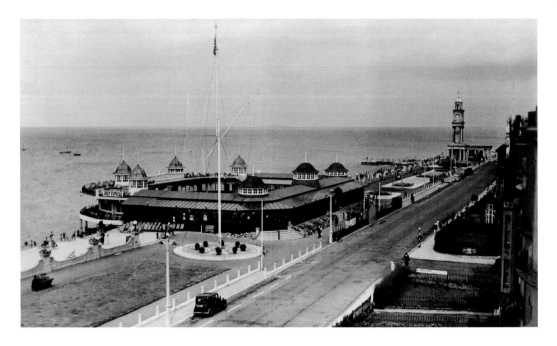

The Promenade in Later Years

Little seems to have changed in Herne Bay over the past few decades. The top picture taken in the 1930s is remarkably similar to the lower view taken in the 1960s. It is only in the past ten to fifteen years that noticeable changes to the seafront have been made. Extensive seafront regeneration took place in the 1990s, including the restoration of the Victorian seafront gardens, which are now a delight to sit in once again. Furthermore, the bandstand was refurbished, made safe and brought back into use for the public.

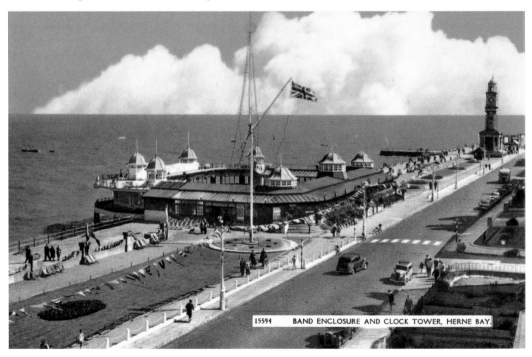

15594 BAND ENCLOSURE AND CLOCK TOWER, HERNE BAY.

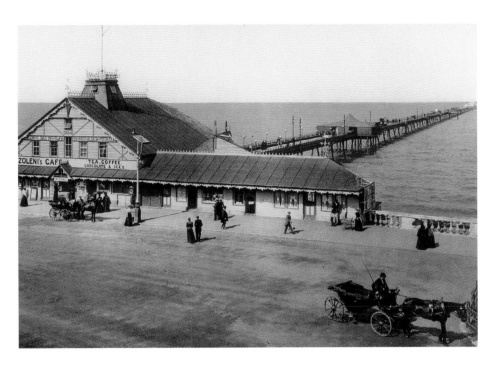

The Changing Face of the Pier

In the hundred years or so that separate these two views, it is remarkable that so many things have conspired to change the face of the pier. Above is how the holidaymakers of 1900 saw pier No. 3, with its fine, curved balustrade taken from the old London Bridge, the concert marquee that was widened when the Grand Pier Pavilion was built in 1910, and the Pavilion itself with shops and Mazzoleni's Café at the entrance. Unfortunately, the theatre, shops and Mazzoleni's Café were all destroyed by fire on 9 September 1928; only the Grand Pavilion survived.

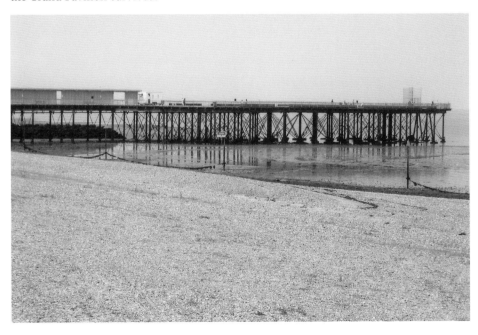

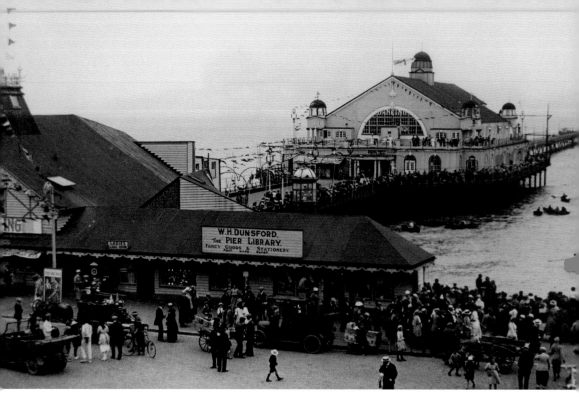

A Final Look at the Pier

Who could resist this final look at the pier with two views taken in 1903 and the 1920s, by which point it had acquired a pier library run by W. H. Dunsford. With so many people milling around, Herne Bay must have been a popular resort. No matter where you look in this picture there are crowds of holidaymakers – unlike that of 1903 which had relatively few people. This early view shows a different face of the pier as it stretches far out to sea, ready to entice the passing passenger ships. It was not destined to be like this for much longer, however, as by 1928 it was burned to the ground.

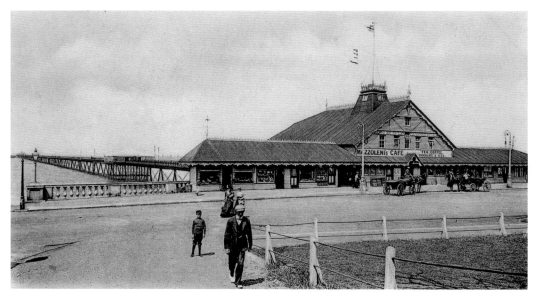

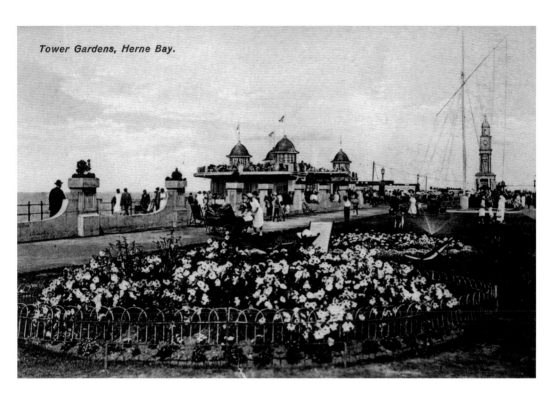

Tower Gardens, Herne Bay.

Tower Gardens

An integral part of the promenade is the Tower Gardens, built to offset the Clock Tower. Even in the 1920s the flower beds and lawns were carefully maintained, but in the 1990s, the entire promenade, including the flower beds, was restored, making it an area of peace and tranquillity once again.

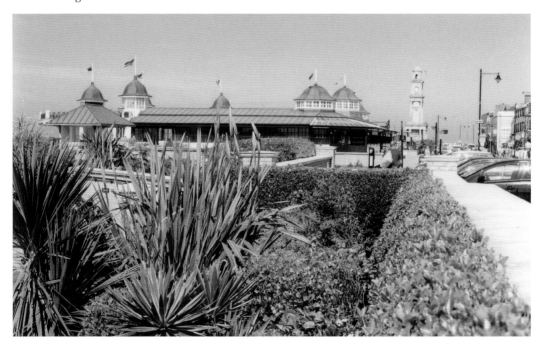

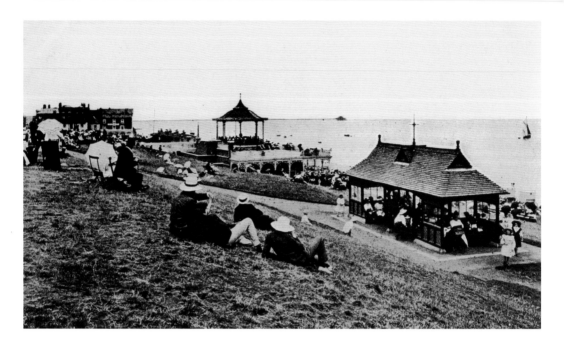

The Downs

What better way to spend a lazy afternoon than sitting on the grassy clifftop of The Downs listening to a brass band concert from the nearby rooftop bandstand of the East Cliff Pavilion? It was a popular pastime judging from the top picture. Today, it is less crowded but still a popular alternative to the hustle and the bustle of the main seafront area. See how the old pier head stands forlornly far out to sea.

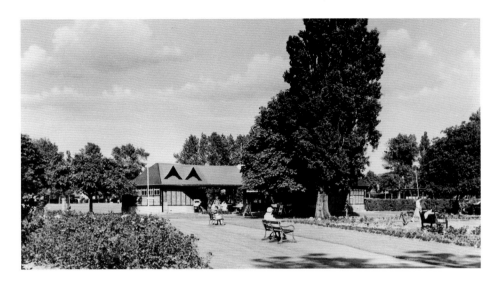

The Memorial Park

Herne Bay Memorial Park was originally conceived as a memorial to those who lost their lives in the First World War, and was completed in the mid-1930s. The plan was conceived because the town was rapidly expanding in size and there was an area of unused, rubbish-strewn land bounded by King's Road, Gordon Road, Station Road and Spenser Road. As it was not suitable for building upon, it was decided to turn it into a memorial park with a lake on its southern side, bowling greens, large grass areas to the north with space for football, cricket and tennis, the whole quartered by pedestrian walkways and a cycle path. At the crossroads there would stand a granite memorial obelisk and opposite, a café and public toilets. From King's Road, an avenue of trees leading through ornate iron gates to the obelisk completed the transformation from a salty, boggy waste ground to an attractive public park. Situated in the heart of the town, it offers a wide range of outdoor activities for the whole community with its formal planted gardens, mature trees, a lake, a play area and several sporting facilities. Sadly, today the brick-built building in the centre of the old view has long gone.

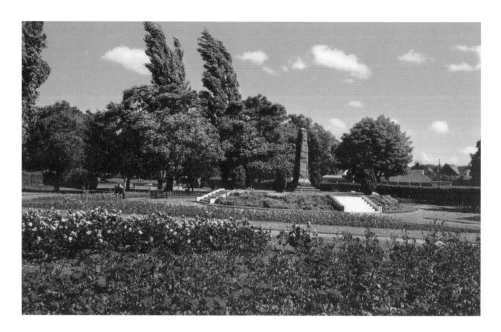

The Memorial Park's Flower Beds

The war memorial garden at the end of a tree-lined avenue has benches and a wonderful display of flowers. It is a tranquil place in which to sit. The park has several planted areas including more formal gardens, sensory gardens and a community kitchen garden maintained by organisations within the local community. For those people looking for a more active time, there are several tennis courts and a large grassed area for ball games. A recent addition to the park is the children's play area with an interesting range of fixed equipment. Access to the park is good, and all paths around the park are surfaced.

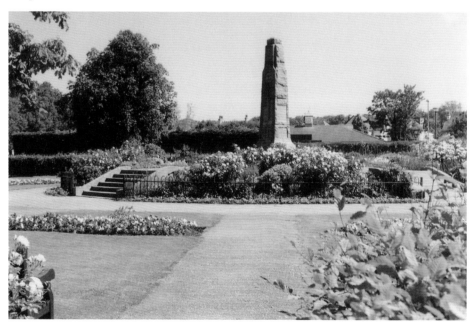

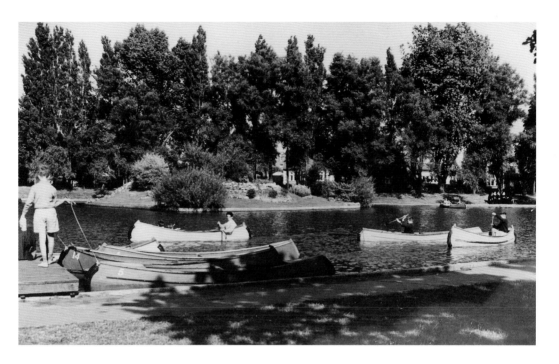

The Boating Lake

One of the many children's amusements in the Memorial Park is the boating lake. The lake is large and, although not available for fishing, it is used for model boats and is home to lots of ducks who are always keen to be fed – they are usually not disappointed.

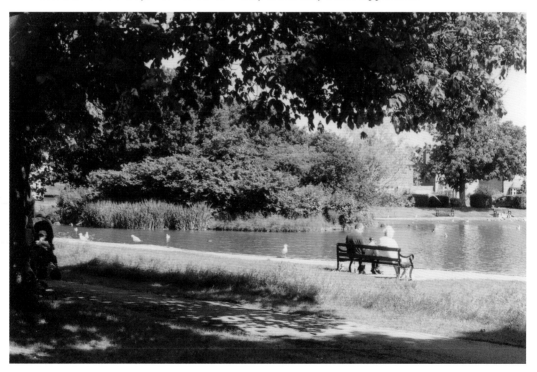

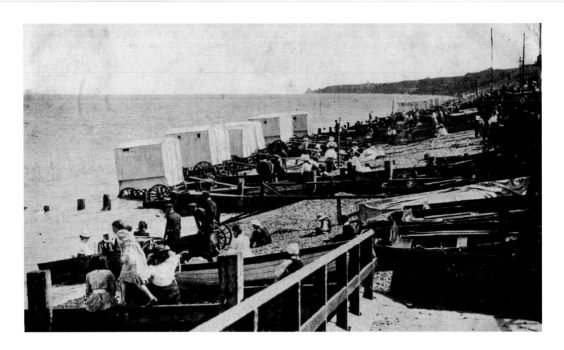

Gipson's Corner

The eastern beach below The Downs was once known as Gipson's Corner according to this postcard dated October 1916. Exactly who or what 'Gipson' might have once been is now hard to say, but I wonder if it might have been something to do with the bathing machines seen here on the water's edge. Could it be that they were owned by a Mr Gipson and this was his corner of the beach? It's a distinct possibility; after all, hiring bathing machines at this time was big business. Today, this same stretch of the beach is less crowded and the bathing machines have not even been replaced by modern beach huts.

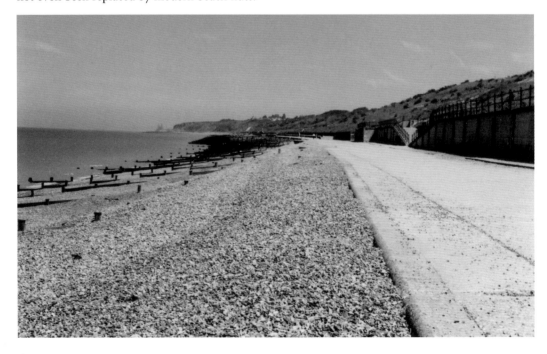

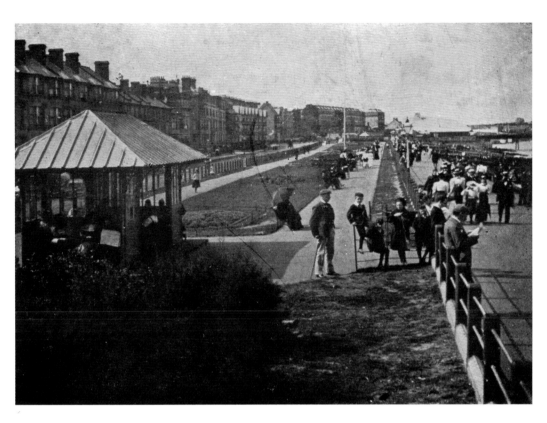

The Promenade Looking Westwards
This was how the promenade looked in July 1906 – more open and less formal than it is today.

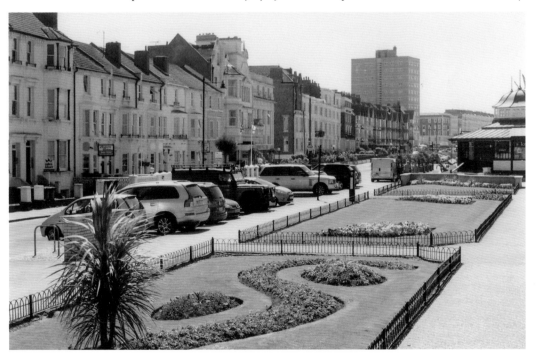

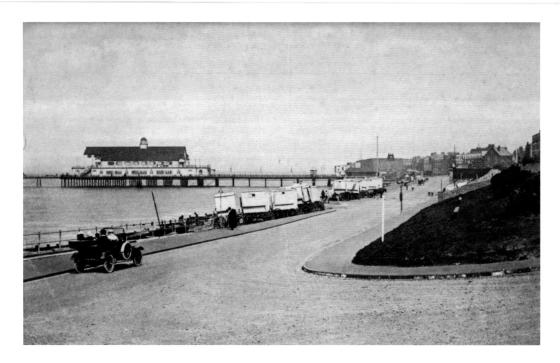

West Cliff

This, for many visitors, is their first view of the seafront and pier. Entering the town via Sea Street, take a left turn into Lane End and this view greets you. Lane End can be seen on the bottom right corner. How much quieter and peaceful it looked in 1921 than it does today, although this modern view belies how it usually looks.

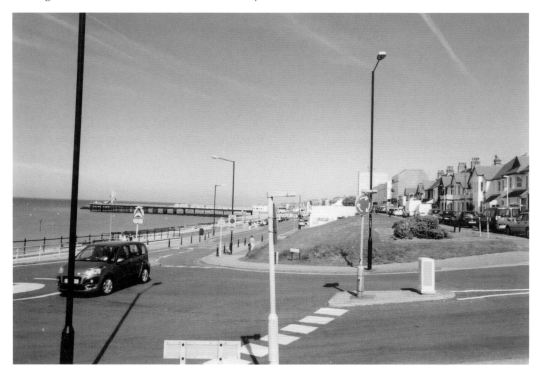

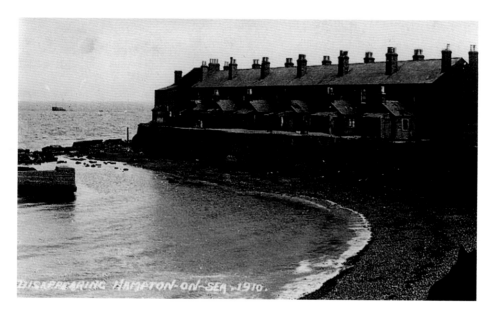

Hampton-on-Sea

If you look westwards from the end of Lane End, visitors will see the remains of Hampton-on-Sea – an abandoned village that has been drowned by the sea as has much else along this stretch of the coastline. It was once a tiny fishing hamlet, but in 1864 it became the property of the Herne Bay, Hampton & Reculver Oyster Fishery Co. It was developed from 1879 by land agents, abandoned in 1916, and finally drowned due to coastal erosion by 1921. All that now remains is the stub of the original pier, the Hampton Inn and the rocky arc of Hampton-on-Sea's ruined coastal defences, which are visible at low tide. Here we can see a terrace of houses, Hernecliffe Gardens, shortly before their demolition in 1910. By 1911 nothing remained, except a short section of the pier in the distance, upon which can be seen the Hampton Inn, formerly known as the Hampton Pier Inn. As a result, the uninterrupted views from the pub and its garden provide an almost 360-degree vista and vantage point for viewing the most spectacular sunsets, bringing in many visitors to enjoy a great pint while gazing out to sea.

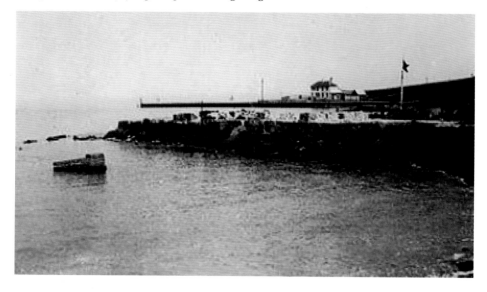

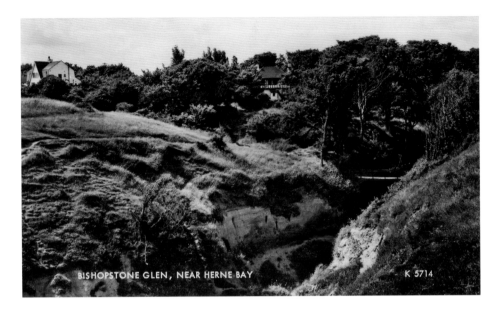

BISHOPSTONE GLEN, NEAR HERNE BAY K 5714

Bishopstone Glen

While Herne Bay's 2 miles of beaches offer a fantastic variety of activities to suit absolutely everyone, if you keep walking along the coastal path for approximately 3 miles you will arrive at Reculver Country Park, a Site of Special Scientific Interest. On the way you will pass through Bishopstone Glen, also known as Oldhaven Gap, where a small stream has cut a valley through the cliffs creating a gap. The sandstone cliffs here provide nesting places for sand martins, and the beaches are famous for fossils and shark teeth. Closer inspections of the cliffs reveal myriad tiny holes that are home to mining bees and rare digger wasps. The trees and shrubs have grown considerably in the intervening years between these two views, but the focal point, the rustic bridge, remains.

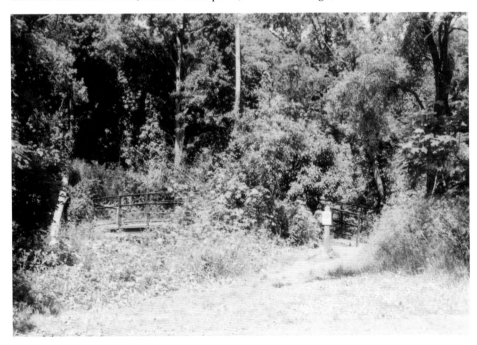

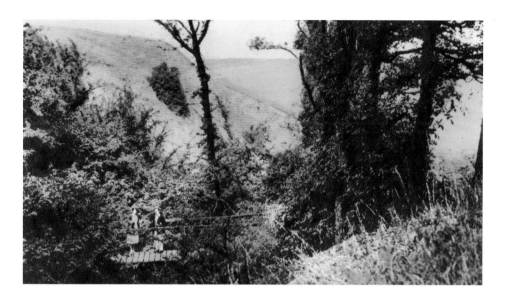

Bishopstone Glen

Such is the fragility of this section of the coastline that by the 1960s the soft clay and sandstone cliffs at Bishopstone Glen had become so unstable that the houses at the top were under threat of destruction. A sea wall was built beneath the cliffs to protect them and a further line of wooden groynes built to protect the sea wall by retaining more of the shingle beach. On the top of the cliff, the clay layer was graded and given a gentler slope to stop it slipping, and drains put in to take away excess water. Grass was planted so that the roots held the surface together, and a monitoring system was installed to detect movements in the cliff. In the 1980s it was decided to extend the defences at Bishopstone Glen, but because the eastern side was part of a protected Site of Special Scientific Interest a less harsh approach was needed. Instead of extending the concrete sea wall, a layer of huge boulders was built up to absorb the energy of the waves. The cliff top was again graded and grassed over to prevent further slumps in the clay layer.

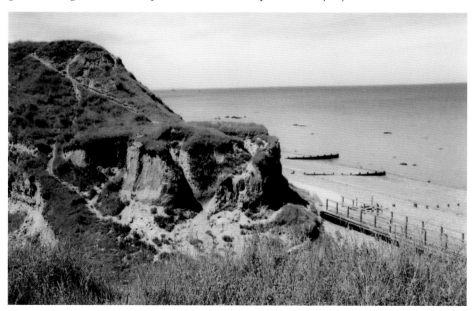

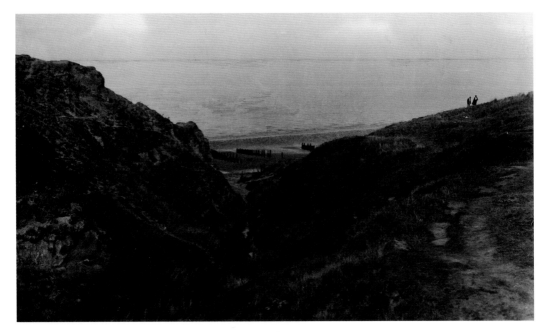

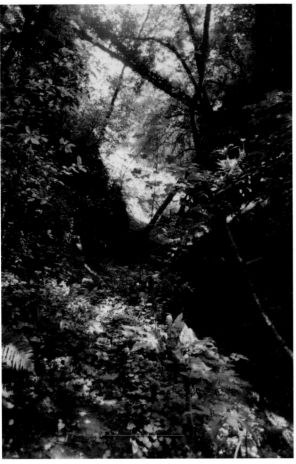

Bishopstone Glen

Here it can clearly be seen how a small stream can effectively cut its way through the softer geological layers to form a valley leading down to the beach. This was how Bishopstone Glen appeared in the 1940s, but today the vegetation has taken control, and it is almost unbelievable that this is the same location. A photographer's nightmare it might be, but this is a haven for wildlife.

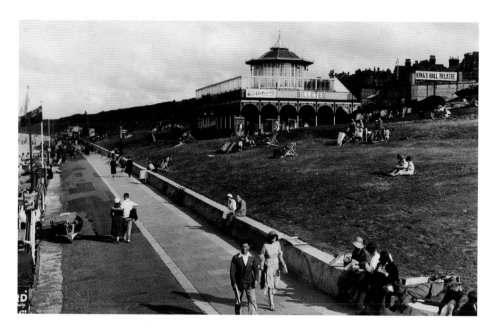

The King's Hall

Beneath the bandstand on The Downs is the King's Hall. Built in 1904 as the East Cliff Pavilion to differentiate it from the Grand Pier Pavilion, it later became the King's Hall (or to give it its full name, the King Edward VII Memorial Hall), which was opened on 10 July 1913 by HRH Princess Henry of Battenberg on behalf of Queen Alexandra. Part of the transformation included rebuilding and extending it underground into the cliff to become a concert hall, theatre and dance hall. Even though the King's Hall is a little distance away from Herne Bay's other attractions, it still enjoys a high profile and is widely used for many different activities. The beach and promenade are still as popular now as they were in the 1950s when this picture was taken.

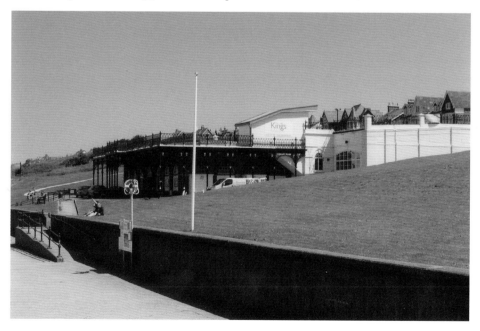

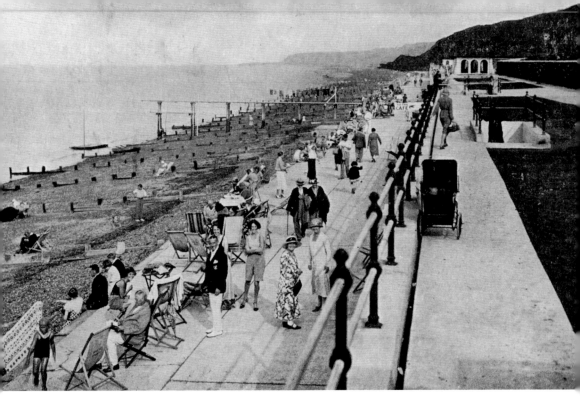

The New Promenade at East Cliff

This view of East Cliff predates the previous view, taking it back to sometime in the 1920s or 1930s. There is no sign of the pavilion that was to become the King's Hall and, as can be seen, it was a popular stretch of the coastline even then. It is more popular with weekend sailors today, as this row of dinghies shows.

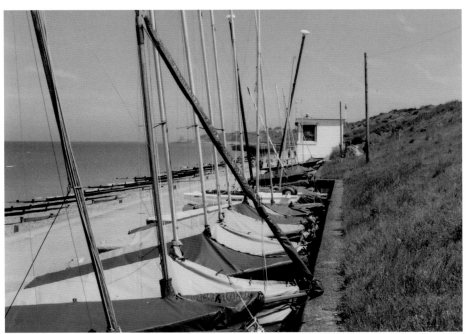

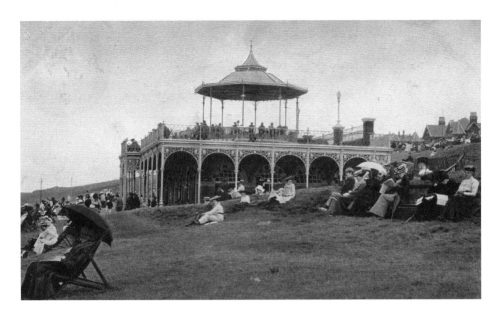

The East Cliff Bandstand

This view of the bandstand in the early 1900s highlights the graceful ironwork that was used not only to support it on its sloping base, but also to make it more eye-catching and appealing. The terraced roof, which as of 2014 still exists, was intended for promenade concerts with an audience of 700. It covers the veranda, supported by iron columns and ornamental ironwork supplied by MacFarlane & Co. of Glasgow in 1904, and is still visible today. The bandstand, which was demolished in 1969, had a roof supported by slender iron pillars. It was fenced with elaborately designed ironwork revealing the influence of the architecture of India during the British Raj period of the architect F. W. J. Palmer. It is a much quieter area today, no longer the popular haunt of those happy to take the sea air and soak up the sun.

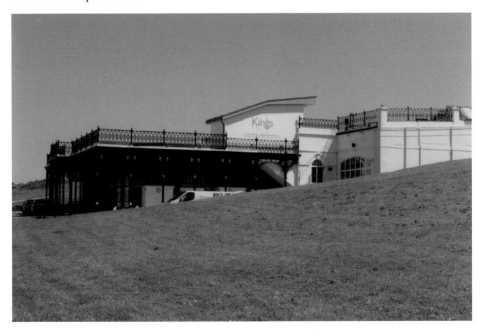

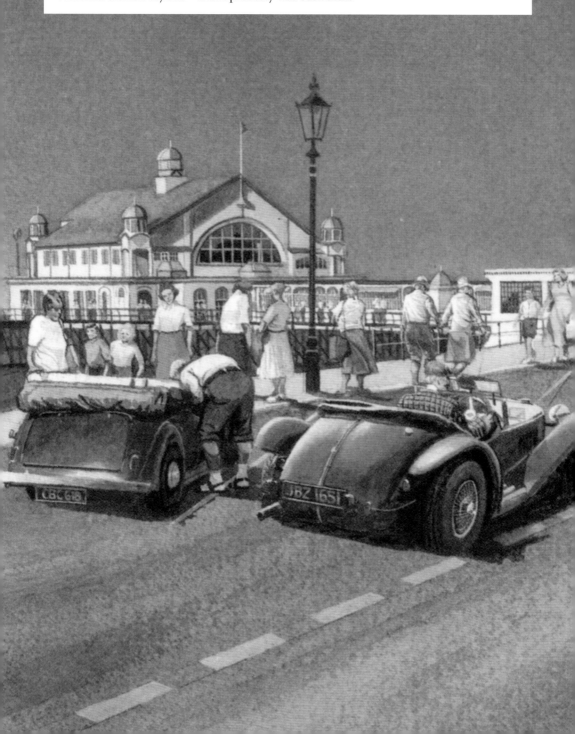

A 1950s View of the Seafront

In the 1950s, Kent artist Geoffrey John Hall undertook a remarkable series of paintings of various local towns and villages. His eye for detail in many of them is astonishing. Here's how he saw Herne Bay in 1958 with its excursion coaches bringing in the day trippers – every young man's dream, an open-top sports car (always a sure-fire way to get a girl!), blue sky and sunshine. It looks idyllica – and it probably was back then.

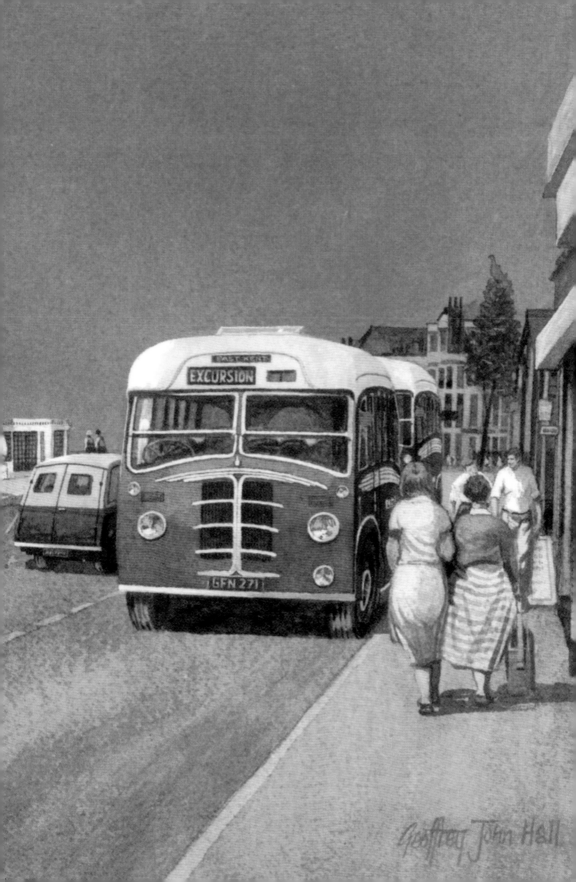

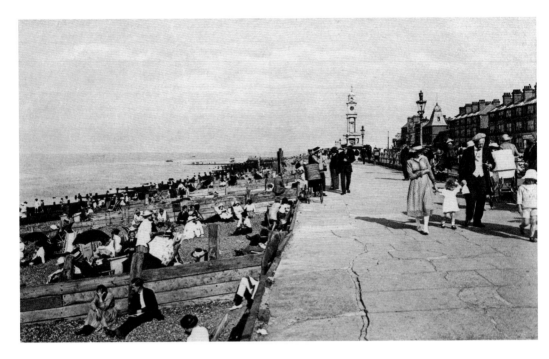

The 1920s Promenade

This view of the beach and promenade must date to pre-1924 because that was the year in which the bandstand was built, and in this picture there is no sign of it. This stretch of the beach was popular as it gave uninterrupted views of the sea and passing ships, unlike today when the view is marred by Neptune's Arm jetty – an unsightly but necessary distraction.

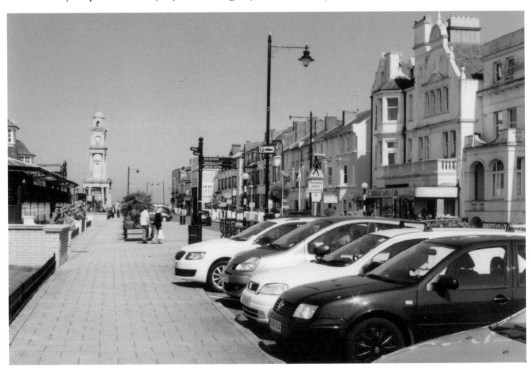

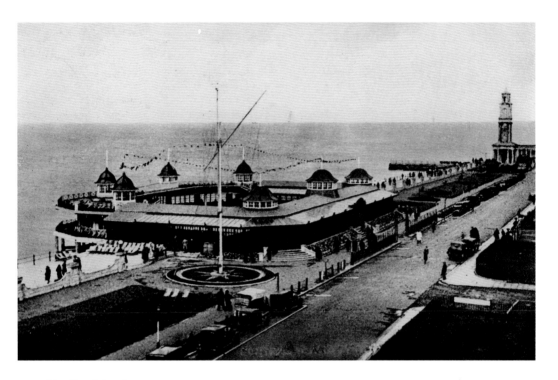

The Bandstand

Just a short time span of thirty years separates these two postcards, both of which appear to have been taken from an upper-floor window of one of the seafront hotels. The top one is postmarked 1936 and, although the bottom one is unused, it has the appearance of having been taken in the late 1950s/early 1960s. Little appears to have changed in that time apart from the installation of a Belisha crossing, and even today the same view is identical.

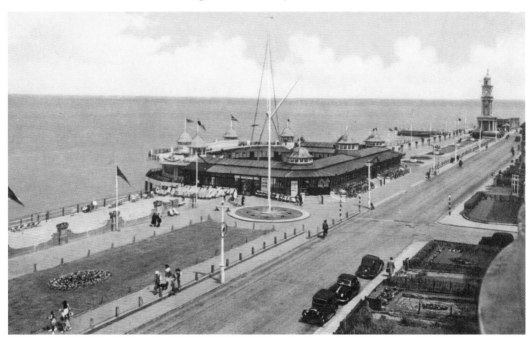

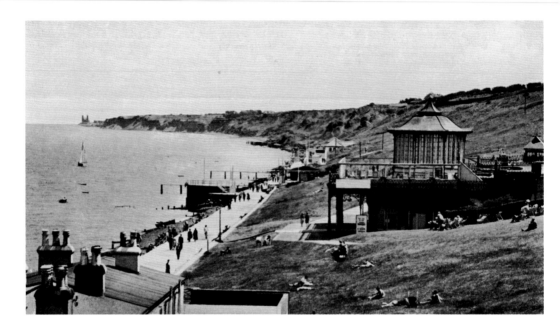

The Downs

Another of those mysterious photographs of yesteryear when the photographer found a high vantage point from which to take his picture, but today it cannot be found. Here we are looking over the rooftops, across The Downs and East Bay, towards the twin towers of Reculver. However, despite the postcard caption stating this is a view of 'The Downs and West Bay', I would suggest this is more likely to be the East Bay, evidenced by the presence of the Bandstand. The rooftops shown in the early view no longer exist; only the platform upon which the Bandstand once stood remains. It would seem that this was a far more popular area back then than it is today.

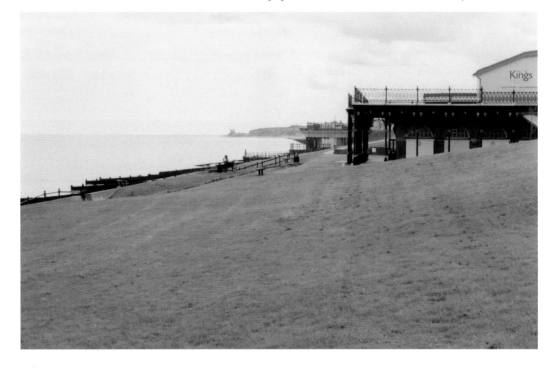

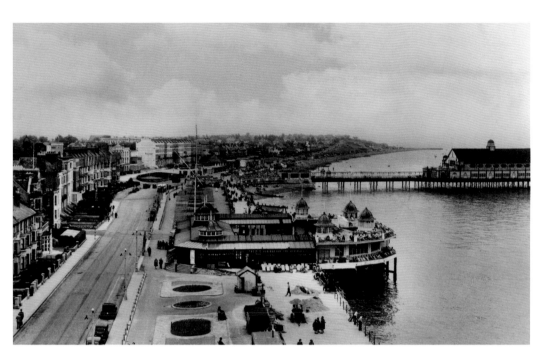

Overlooking the Sea

Of all the views of the bandstand seen so far, none illustrates the relationship between it and the sea at high tide better than this undated view. The photograph was taken at a time when people were allowed to access the upper and lower terraces, and sitting here, enjoying the sunshine and sea breezes, would have given an even greater sense of being on a ship at sea, than would have the pier. At the top of the picture, as the coastline recedes into the distance, can clearly be seen the pier at Hampton-on-Sea, now all but demolished and referred to earlier in this book.

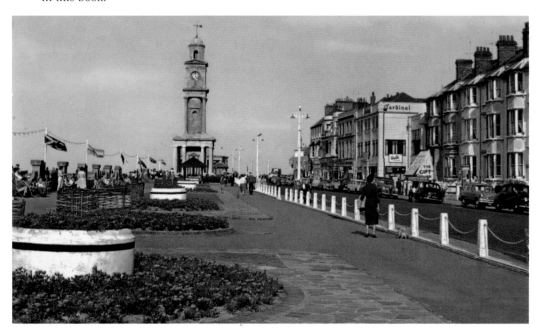

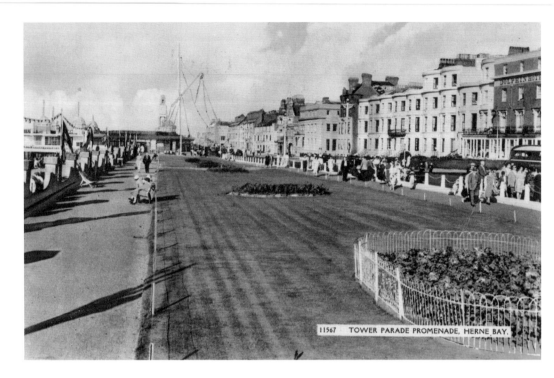

11567 TOWER PARADE PROMENADE, HERNE BAY.

Tower Parade

For many years the flower beds and garden of Tower Parade remained unchanged, looking very similar to gardens of other coastal towns throughout Britain, but in the 1990s they underwent a radical redesign. This was so successful that these wonderful seafront gardens have now become an important part of Herne Bay in Bloom. As an entrant in the South and South East sections of the Britain in Bloom competition, Herne Bay won gold in 2011.

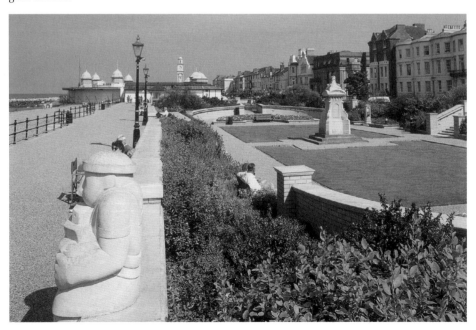

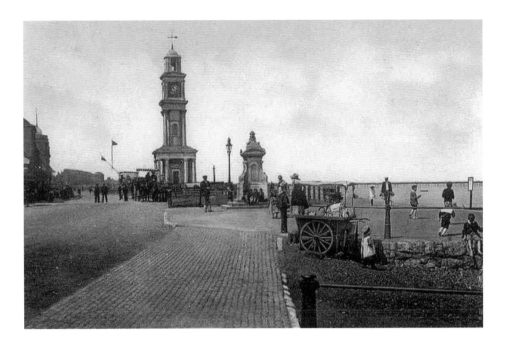

The Jubilee Fountain

The Portland stone fountain was a gift from London alderman, Col Horatio Davies, Sheriff of London and Middlesex from 1887/88 and later Lord Mayor of London, for the Jubilee Memorial of Queen Victoria's reign. It stood beside the Clock Tower from 1888 until March 1993 when it was re-erected in the Waltrop Gardens between the bandstand and the pier. Waltrop Gardens face Telford Terrace and is a quasi-Victorian sunken garden built to celebrate the twinning of Waltrop and Herne Bay. As well as the Jubilee Fountain, the garden also contains a sundial on the seaward side, which was a gift from the town of Waltrop, designed by the burgermeister Herr Jochen Mungner.

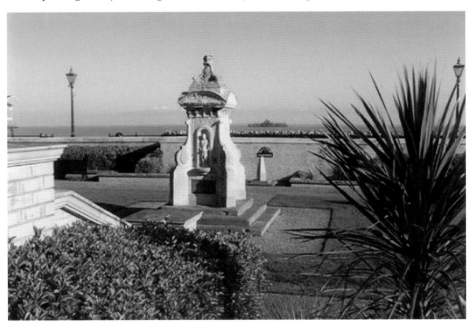

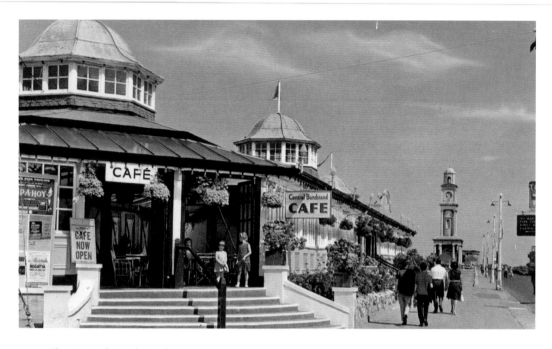

The Central Bandstand

Even though just forty years separates these two views, it can be seen how the focus of attention of the bandstand has shifted from the exterior to the interior. Back in 1970, this corner of the building was the entrance to the café, and most welcoming it looked too. Today, this is the entrance to an Indian restaurant and bar, and the café is located in the opposite front corner, generally accessed from the interior of the bandstand. The area once filled with people enjoying the band concerts is now filled with tables, chairs and people enjoying a drink al fresco.

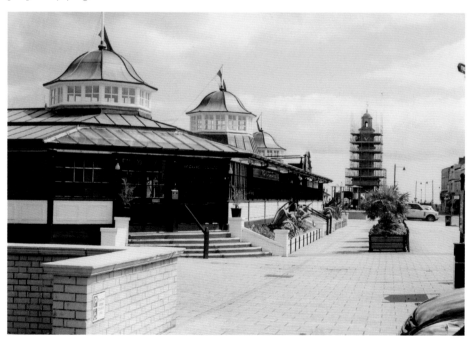

The Changing Face of the Pier

Part of Herne Bay's charm is its ever-changing seafront appearance and subtle changes to the townscape, which are also constantly being introduced. This is how visitors would have seen the entrance to the pier in the 1960s and '70s. With the pavilion now demolished and the entrance kiosks gone, access on to the pier today is a totally different experience. It somehow lacks that 'pier approach' feeling of enticement. Piers used to extend a welcome to holidaymakers, promising all manner of attractions, but today this pier has little to offer.

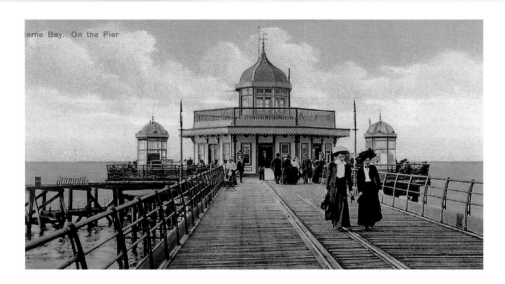

The Pier Head

Because of the distance the tide recedes over a relatively flat and shallow seabed, for ships to be able to moor at the pier head, to disembark their passengers at all states of the tide, piers at resorts in the Thames Estuary needed to be long. Herne Bay's third and final pier at 3,787 feet (1,154 metres) was the second longest in England. Such was the length of these piers their operators thought it necessary to install a tram, and in this early view the track can clearly be seen as two Edwardian ladies 'take the air'. Behind them is the new 1899 restaurant at the pier head, which later became a ticket office and cafe and still stands today – but only just. It is wooden, octagonal and domed, and had a promenade deck on the roof. In June 1940, the army demolished two sections of the pier between the pavilion and pier head to prevent the enemy from landing, then crossed the gaps with Bailey bridges. It has been suggested that the gaps and Bailey bridges weakened the pier structure, thus increasing the storm damage of 11 January 1978. A further storm in February 1979 caused progressive collapse of the central portion of the pier between the two Bailey bridges, and its remains were dismantled in 1980, leaving us with what we have today.

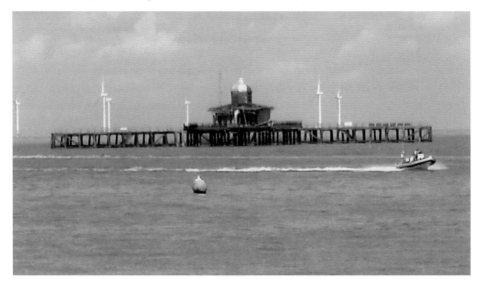

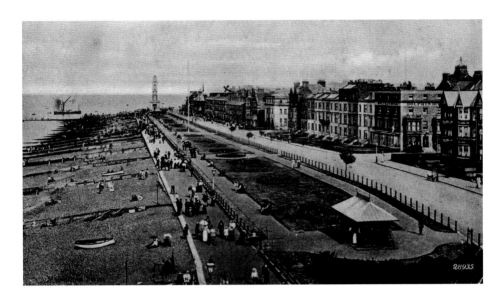

The Early Esplanade

I found this early view of the esplanade quite appealing. It is not dated and the postage stamp bearing a date has been removed, so few clues remain. The bandstand has yet to be built, so that dates it to pre 1924 and the dress worn by those strolling along supports this. The Clock Tower is in place, but that dates it to post 1837, which is too early. It is known that the promenade was paved and the Tower Gardens were laid out in the early 1920s, so we can safely say this picture was taken in the late 1800s/early 1900s. It is such a pristine, uncluttered scene and the road is totally devoid of any traffic, unlike today. One mystery remains unanswered; however, where did the early photographer stand to take this picture? It appears to be from a high vantage point, but even the roof of the pier pavilion would not have been high enough. Today, with no similar high vantage point, I had to settle on a ground-level view.

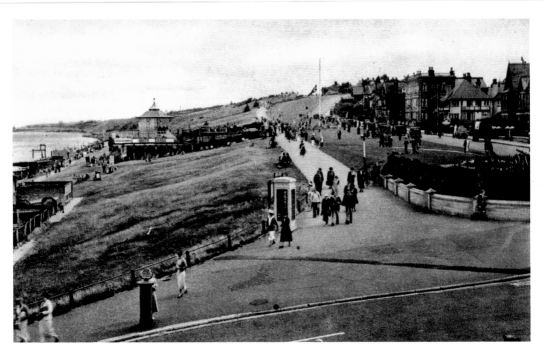

Beacon Hill

Beacon Hill must surely be able to lay claim to having the best outlook in all of Herne Bay as its houses look out across the grassy expanse of The Downs to the sea beyond. It is certainly a popular area in which to walk, judging by this view from the 1930s.

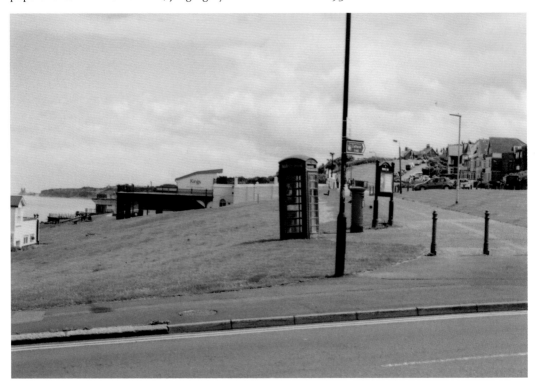

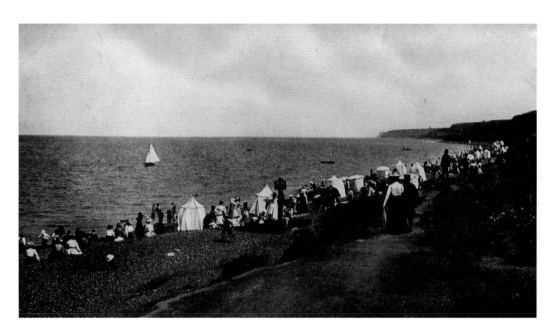

East Beach

Even though the East Beach, just below The Downs, is some distance away from Herne Bay's main attractions like the pier, bandstand, larger hotels and the seafront shops, it was still a popular spot in the early 1900s, probably because of its remoteness. The bathing machines have given way to tents for bathers to change in, but today none of this popularity remains. It has become another of Herne Bay's quiet beaches with not even a refreshment kiosk close by.

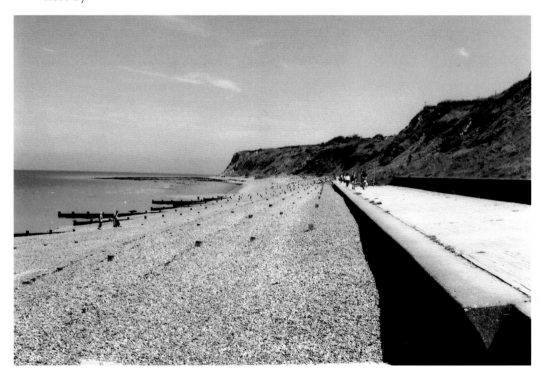

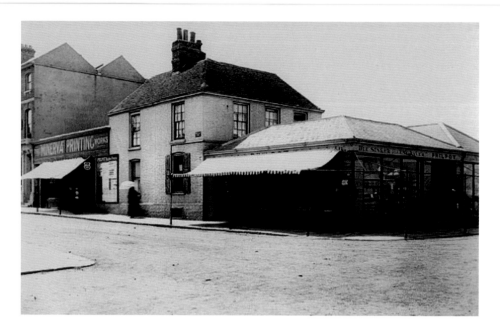

The Old Post Office

A familiar seafront coffee bar is Makcari's, situated on the corner of Central Parade and William Street. It is a town landmark familiar to many visitors. The property was built in 1860 and was originally the town's post office. The top picture, which was taken in around 1890, clearly shows that it also traded in fancy goods, stationery and gifts. It was owned at that time by A. W. G. Philpott who bought it from John Banks, whose mother, Maria, had originally run the post office. The business was later bought by the Macari family who changed it to an ice cream parlour until it was taken over by the Hassan brothers who kept the Macari name but subtly changed it by adding the letter 'k'.

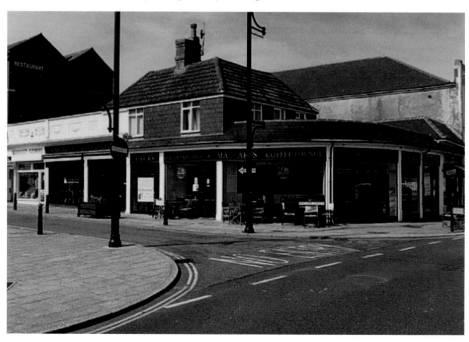

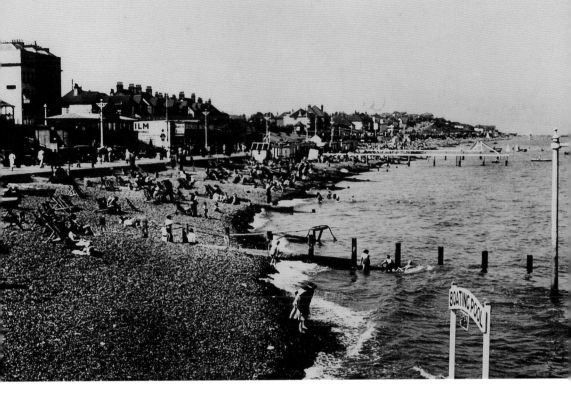

The West Beach

Looking westwards from the pier towards Hampton-on-Sea. This is still one of Herne Bay's more popular beaches. Here we have two views – the top one taken in the late 1940s, beneath which is one taken in the 1970s. It is still just as popular today.

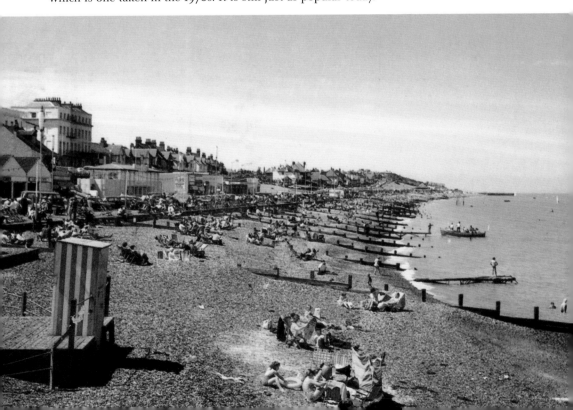

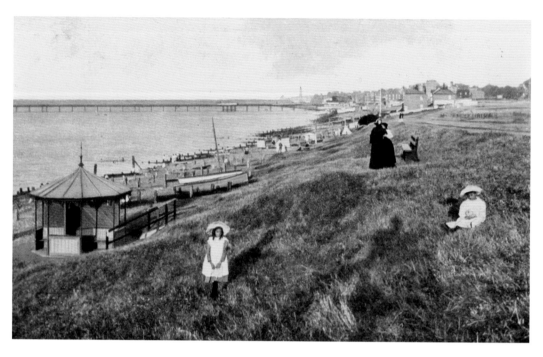

West Cliff

What an idyllic picture of the early 1900s. Clearly on show in the background are the pier and the Clock Tower. Postmarked August 1912, how quiet and peaceful this section of the beach looks compared to today when your view of the beach is marred by a line of beach huts.

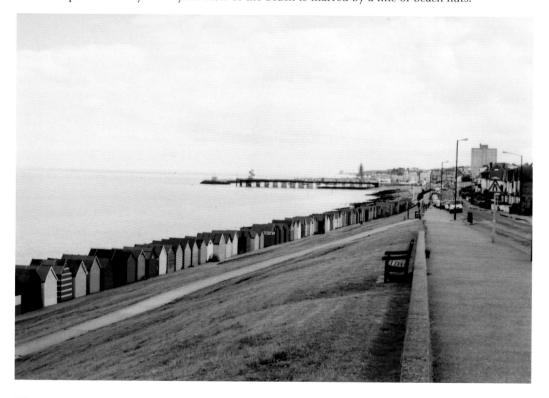

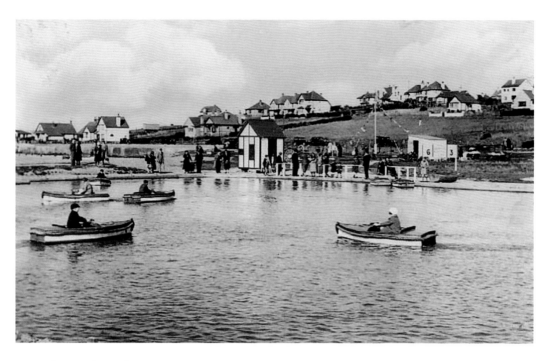

The Boating Lake at Hampton

Take a short walk along the coast, to the west of Herne Bay and you'll come to the delightful residential suburb of Hampton-on-Sea. Attractive houses and bungalows line the bay; it is exactly how you would imagine living by the sea to be. It is hard to believe that this was once a tiny fishing hamlet, but because of constant coastal erosion was abandoned in 1916 and finally lost to the sea by 1921. Hampton once had a popular boating lake, the remains of which today lay beneath this children's play area. Interestingly, many of the houses on the slope in the background can still be picked out in the modern-day view, even though many more houses have been built since.

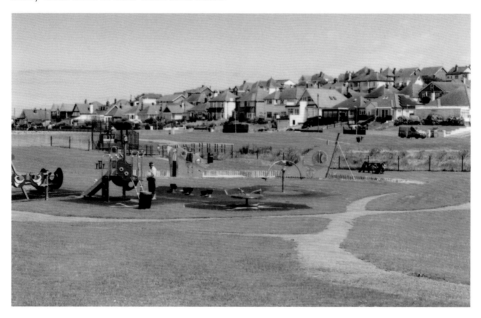

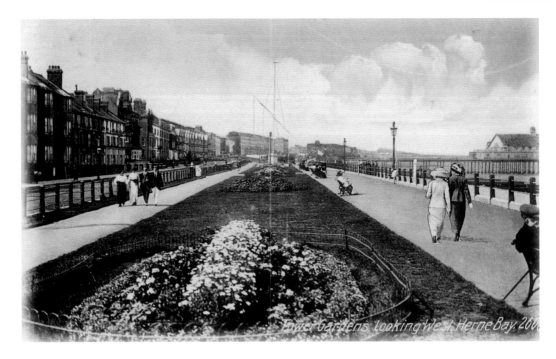

Tower Gardens

Originally laid out to complement the Clock Tower, the Tower Gardens remained unchanged for many years, but in the 1990s underwent a radical change to take it into the twenty-first century. Today, it is not so much an area of the promenade you can walk past, but one that invites you in to sit and admire the flower beds.

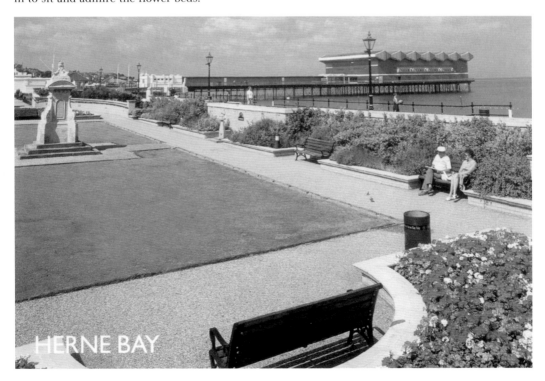

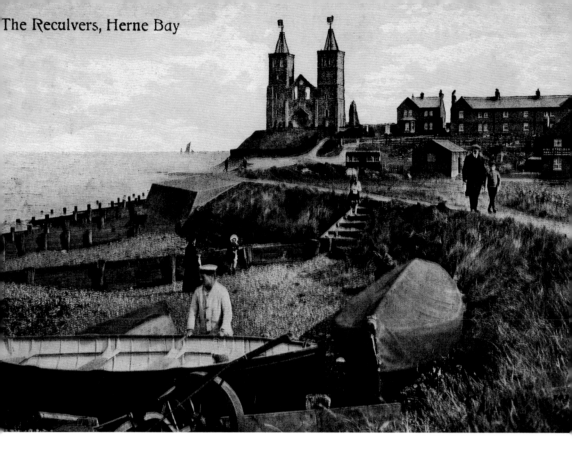

Ever-Changing Seashore

Today, the seashore at Reculver is hardly recognizable from how it once was, due largely to the constant threat of erosion by the sea. Such is the severity of this that a substantial sea wall has had to be constructed to keep the sea at bay.

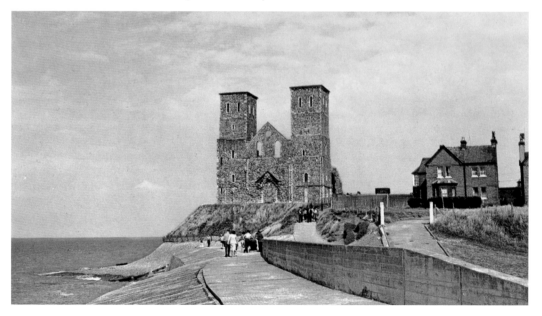

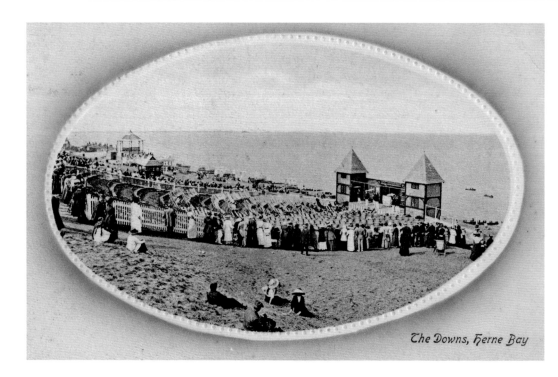

The Downs, Herne Bay

Competing Entertainment Centres

By 1912, The Downs, to the east of Herne Bay's main seafront, was offering serious rivalry in entertainment to that on the pier and the promenade. As can be seen in the picture above, it had a bandstand as well as a stage area, both of which regularly drew in large audiences. The naturally sloping grass slope made for an ideal auditorium. By 1978, however, with changing tastes in entertainment, the bandstand was no longer being used and the stage area had vanished.

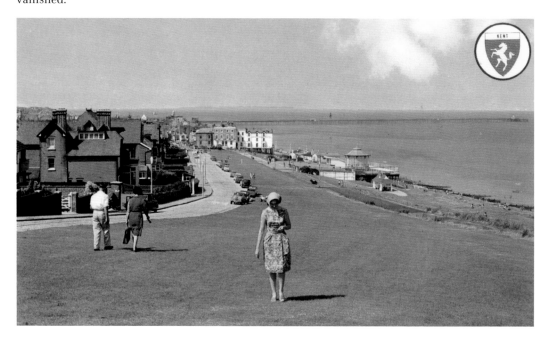

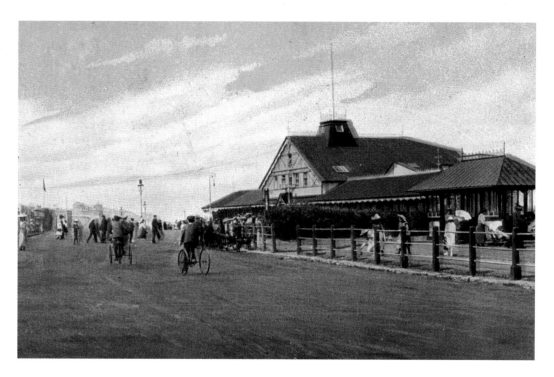

Opposite Ends of the Pier

How very different these two views of the early pier are. At the top is what greeted visitors as they approached the pier from the promenade in 1906. Below is a 1913 view of the pier head some 3,787 feet (1,154 metres) away, far out to sea. This little building was designed as a tearoom, but was later converted to a ticket office for those wanting to board a passing ship.

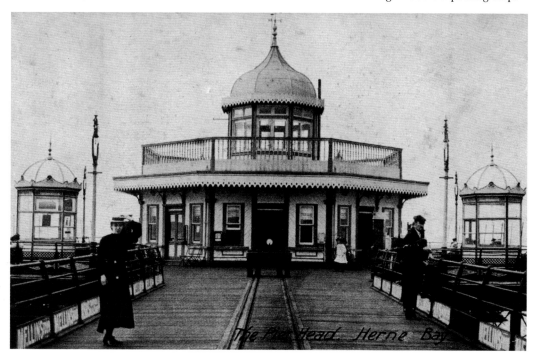

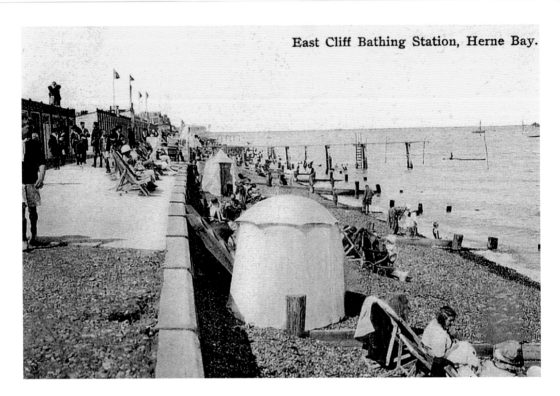

East Cliff Bathing Station, Herne Bay.

East Cliff Bathing Station
Thought to have been taken in the 1920s or 1930s, as can be seen, this was once a popular stretch of the beach with beach huts on the promenade and changing tents on the beach itself. Moving on to 2014, with the beach huts now gone, this has become a quieter area – more as somewhere you pass through rather than head for.

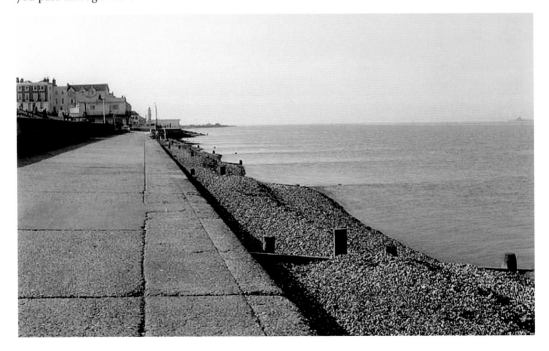

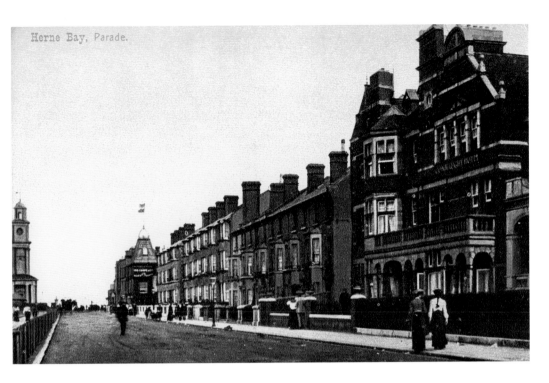

A Never-Changing Streetscape

I think part of the charm of Herne Bay is the fact that its seafront streetscape has never altered. Today, it still looks exactly as it did in this early twentieth-century view. In many other seaside resorts the terraces of hotels and guest houses have been changed into cafés, amusement arcades etc, but not in Herne Bay. It still retains its early seaside resort character. That's not to say it is lacking in seafront amenities, which are present at either end of the seafront.

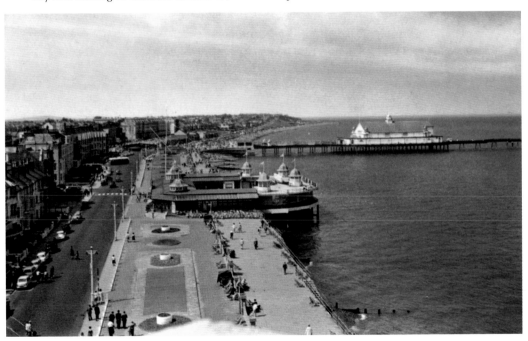